Praise for *Figure It Out*

"Does contemporary American literature offer any greater pleasure than the polymorphous brilliance of Wayne Koestenbaum? These essays are extraordinary."
—GARTH GREENWELL, author of *Cleanness*

"'Imagine, then, an ecology of language,' Wayne Koestenbaum writes. He creates one of magical abundance here. Instincts and insights flourish, as do ideas and sensations. He speculates, he cogitates, he provokes and delights. He's a scamp, he's a seer, and he's a virtuoso."
—MARGO JEFFERSON, author of *Negroland*

Praise for Wayne Koestenbaum

"[Wayne Koestenbaum] is a figure of this time, but he also is a writer and thinker for all time. His career streaks above this genre-obsessed, professionalized-writer moment, and corresponds instead to the history of the polymath, the public intellectual, the drifter, the infinite conversationalist."
—MAGGIE NELSON

"Wayne Koestenbaum is one of the most original and relentlessly obsessed cultural spies writing today. His alarmingly focused attention to detail goes beyond lunacy into hilarious and brilliant clarity."
—JOHN WATERS

T0020902

"I'll go wherever putto, poet, painter, and—little did you know—lounge crooner and ivory tinkler Wayne Koestenbaum wants to take me." —RACHEL KUSHNER

"Koestenbaum is an exuberant critic, enraptured poet, intoxicated historian . . . Of course it is one thing, as a writer, to aspire to or even practice impure forms and an ecstatic style—quite another to take seriously the ethical field onto which they open. In the end, for all the wildly admirable qualities of his writing, I think the essential contribution of Koestenbaum's diverse project is to reassert what Walter Benjamin called 'the fullness of concentrated positivity' (a phrase of which Sontag approved) in the face of the fleeting attractions of polemic, dispute and snark. There is assuredly a politics to this, an urge to keep all possibilities in play, and to keep play alive as a possibility, in a time of anxiety and retrenchment. I can hardly think of a writer who is so exacting about his own enthusiasms, so diligent in his pursuit of joy, so principled in the defence of pleasure." —BRIAN DILLON, *Frieze*

"Nouns! Nouns blue, humid—and rare! I've never thought about them more, nor felt that darkling word crawl up my pant leg as I do now when I read the irrepressible Koestenbaum. The guy is not without genius, mischief or gonads. When the lurid steam clears, his bedewed lines coruscate amidst hot shadows that leap with a kind

of pink spermy glee. Hilarious, gorgeous, intellectually playful, fairy-light . . . all in ways I've NEVER encountered before! Utterly thrilling!" —GUY MADDIN

"Like an impossible love child from a late-night, drunken three-way between Joan Didion, Roland Barthes, and Susan Sontag, Wayne Koestenbaum inherited all their stylistic wonder and laser-beam smarts, but with the added point-blank jolt of sex." —BRUCE HAINLEY, *Bidoun*

"There's always a sense in Koestenbaum's writing that indulgence and risk are countered by extreme care at the level of the line or sentence . . . If you haven't noticed by now: here is one of the most flirtatious writers around."

—*Artforum*

"What Koestenbaum has achieved, perhaps better than any other contemporary poet, is linguistic fecundity combined with hyper-fastidiousness. Words seem to fall out of his mind and through his pen at breakneck speed without undermining the deeper aesthetic experience . . . The psyche is dangerous terrain, and Koestenbaum is, among all his other accolades, an exceptionally brave explorer."

—CODY DELISTRATY, Poetry Foundation

"For a quarter century, since the publication of the seminal queer theory text *The Queen's Throat*, Wayne

Koestenbaum has been one of our leading gay cultural critics. Alongside his parallel careers in poetry and the visual arts, Koestenbaum has been responsible for some of the most penetrating and haunting literature on queer identity, subcultures, and fixations." —*Out*

"Koestenbaum's reflexivity is uncanny and gathers pathos from the very task of writing, which for him is tantamount to assembling a self. As Foucault put it, being gay 'is not to identify with the psychological traits and the visible masks of the homosexual, but to try to define and develop a way of life.'" —FELIX BERNSTEIN, *Bookforum*

"Wayne's work—his poems, his essays, his criticism—obliterates any vestigial divide we might hold on to between play and thought. It revels in and broadcasts the risks and joys (the risky joys and joyful risks) inherent in both." —STEFANIA HEIM, *Boston Review*

"[Wayne Koestenbaum's] writing is pungent, replete, intoxicating, infectious. I read it and I want to make it my own, to steal his precision and lyricism and immaculate means of evoking the spectacularly specific." —ANNE HELEN PETERSEN, *The Hairpin*

"There's anxiety in Koestenbaum's work. There's wonder here, too, and the combination of the two give me a critic

that I not only want to read but a critic I want to get to know. It's human to worry, and writing about these worries is a perfect bonding agent." —*Bookslut*

"This scholar of excess is off the cuff, over the top, and always on the money!" ELAINE EQUI

"Impassioned insight . . . By turns comic and elegiac, respectful and blasphemous . . . Little or nothing escapes [Koestenbaum's] gaze." —*Newsday*

"Whether referencing *La Bohème*, Donald Winnicott, bondage gear, Brooke Shields, or a haunting dream of massaging a baby, Koestenbaum's work entices in all its sui generis, subconscious musing." —*Publishers Weekly*

FIGURE IT OUT

FIGURE IT OUT

Essays

WAYNE KOESTENBAUM

SOFT SKULL NEW YORK

First Soft Skull edition: 2020

Library of Congress Cataloging-in-Publication Data
Names: Koestenbaum, Wayne, author.
Title: Figure it out : essays / Wayne Koestenbaum.
Description: First Soft Skull edition. | New York : Soft Skull Press,
2020.
Identifiers: LCCN 2019042322 | ISBN 9781593765958 (paperback) |
ISBN 9781593765965 (ebook)
Classification: LCC PS3561.O349 A6 2020 | DDC 814/.54—dc23
LC record available at https://lccn.loc.gov/2019042322

Cover design & Soft Skull art direction by salu.io
Book design by Wah-Ming Chang

Published by Soft Skull Press
1140 Broadway, Suite 704
New York, NY 10001
www.softskull.com

Soft Skull titles are distributed to the trade by Publishers Group West
Phone: 866-400-5351

Printed in the United States of America
1 3 5 7 9 10 8 6 4 2

for Lisa S. Rubinstein and Steven Marchetti

CONTENTS

I

II

III

IV

I

DO YOU WANT TO TOUCH IT?

On the New York subway, a fellow passenger's leather bracelet caught my eye. The bracelet, two inches wide, advertised not a specific sexual predilection but a general advocacy of extreme taste. He wore several bracelets; the others, more slender than the leather one, grouped themselves on either side of the primary band. Over his shoulder hung a canvas bag bearing the word *Alpha*, in a spacious font—an aerated font, susceptible to unsolicited infusions. I was wearing a blue coat; I call it my Picasso jacket, not because Picasso ever wore such a jacket, or because the jacket resembles one of his paintings, but because I need to discover a name for every desirable object that surrounds me. When I first owned the blue jacket, I didn't necessarily find it desirable, but I enshrouded it with desirability by granting it a name—the Picasso jacket—it didn't deserve. Picasso was a portly man; we've all seen pictures of him topless. Imagine his chest—its width, its arrogance, its suggestion of primacy and sway. Perhaps you find chests like Picasso's desirable. My chest doesn't resemble Picasso's, though perhaps mine is a

finer specimen; mine is less weather-beaten, less flabby, less hairy. I will never be able to achieve, in art or letters, what Picasso achieved. (Who among us can?) But my chest is not to be held accountable for the paucity of my gifts. My chest, like a rook in a chess game, has a valuable neutrality of demeanor, a lack of psychological attributes. The rook is not an individual; the rook is a reminder of larger issues—or perhaps a *remainder* from battles and tempests that occurred long ago.

✦

On the subway, I engaged in a staring contest with the man wearing a leather bracelet and holding an "Alpha" bag. I won. At a certain point, as our train neared 53rd Street and Lexington Avenue, he broke off eye contact with me.

✦

An hour later, in a design showroom where I was offering prizes to winners of a contest, a competition rewarding supplicants who could meld the practicalities of industrial design with the floridities and nebulosities of landscape painting, I saw again the man with the leather bracelet. Our eyes met; he looked away. I took the plunge, walked up to him, and asked him the significance of the word *Alpha* on his bag. He told me its meaning, but I'm

not at liberty to reveal it to you; if I gave you more infor
mation about the company he represents, a firm whose
name contains the word *Alpha*, you could google it, and
find his name—he is the operation's leader—and doubt-
less find his picture, as well. Seeing his picture, you would
understand why he arrested my sight on the subway; you
would know more about the nature of my desire than I
wish to betray. You would understand that the leather
bracelet was not the main reason I was staring at him.
You would understand that my allusion to the leather
bracelet was a displacement.

✦

The stranger with the "Alpha" bag was a visitor from
South America; he spoke Portuguese and Spanish, but
no English, so I spoke Italian to him. In error, I said *pros-
simo*, which means, in Italian, "next," but I'd meant to say
"earlier," or whatever Italian word means "earlier." At the
moment I don't know what Italian word means "earlier,"
and I don't want to interrupt the process of composition
by consulting an English–Italian dictionary. My devotion
to the writing trance's inviolability is a throwback to an
earlier moment in the history of taste; trying to narrate
this simple episode to you, I find myself in the grip of
an aesthetic style that, if I were a mature writer, I would
have outgrown. Obscenity resides in using methods that

history has declared obsolete. A full century after Cubism made fracture possible, why am I trying to reproduce this afternoon's reality in sequential sentences, rather than presenting to you an asyntactic, askew distillation of the events, filtered through a presiding consciousness? Why is the consciousness overseeing the narration of this fable so lacking in discernment?

✦

After the awards ceremony for the supplicants who'd attempted to weld together the arts of industrial design and landscape painting had ended, and long after my enigmatic acquaintance from the subway had left the showroom and I had said goodbye to the supplicants, both those who had received awards and those who had not (I gave especial praise, in my formal remarks to the assembled audience, to those supplicants who had not won a prize, because I always prefer the losers to the winners), I saw, on the elevator ride down to the lobby, a young man with a dense beard. We were the only passengers. I don't usually speak to strangers in an elevator, but an impulse of transparency and boldness overtook me, and I turned to the stranger and said, "Your beard is sensational." He said, "Thank you." I decided to express my admiration for his beard in a more detailed and effusive fashion. I praised his beard's density. I used the word *thorough*.

I might have said, "Your beard is very *thorough.*" The beard left nothing out; it lacked ellipses. He said, "Do you want to touch it?" I reached out and felt his beard: rough, dimensional, forthright, it was mostly brown in color, though an underlying redness struggled to break free and achieve dominance. The moment of palpation lasted only five or ten seconds. As we exited the elevator, I asked his name. "Ezra," he said, shaking my hand. I told him my name. I didn't tell him that I'd written my undergraduate thesis on Ezra Pound. I wondered, afterward, whether Ezra is usually a Jewish name. I wondered whether the Ezra in the elevator was Jewish. I wondered if my galvanized reaction to his beard stemmed from my intuitive sense of his Jewishness. I wonder now, as I write this allegory, why I considered Jewishness to be a bedrock matter, lending coherence to all attributes of the person, including the thickness and thoroughness of the beard.

✦

I considered the day a festival of rich encounters. Neither encounter—with the man on the subway or the man on the elevator—would likely bear fruit in further conversation or friendship. Ezra and the man from Alpha, I will probably never see you again. And yet you are firmly lodged in my system of magical references. If I said that you symbolize for me the suggestiveness of accidental encounters,

I would be saying nothing precise, for the word *suggestive* has no meaning without an indication of what is being suggested. Perhaps, however, my subject here is simply *suggestibility*—the capacity to receive suggestions. No hypnotist has stronger sway over me than a stranger; even the notion "stranger," however, is a mesmerizing fiction, thick with ideology, dense with assumptions about lands, borderlands, and the firm divisibility of the known from the unknown. The German word for stranger, *Fremde*, reminds me of Frieda Kahlo, of a ghostly Frieda generations ago in my family tree, of Sylvia Plath's daughter (Frieda Hughes), and of unfriendedness, as if the English word *friend* had been mingled with alien consonants, in a game involving rope, a game in which the hands of the competitors inevitably suffered rope burn; "friend," within a consonantal rope-game, becomes *Fremde*. I suppose that this essay, this fiction, is an allegory about different countries coexisting. It isn't traditionally a writer's business to decode her own parable. But I like to clean up after myself. If I make a mess, I take out a whisk broom, a sponge, or a mop. The mop I'm dragging across my prose's floor, at the moment, is the allegory mop. I need to mop up the messy particles I've spilled on the floor, and be sure that I leave the surface as shiny and blank as I found it.

(2017)

MY NEW GLASSES

I went to Alain Mikli to buy new glasses, and I came away with glasses by his son Jeremy Tarian. Heir vibe, obedient-patriarchal-descent vibe, suffuses my new frames. From the outside, they seem pure black/ blue. Take them off my head, however, and look more closely: they're pocked, variegated with transparent slivers. Schismatic pockets interrupt the monochrome. I'm wearing *interrupted glasses:* coitus interruptus. Man glasses, Mafia glasses, Aristotle Onassis glasses: the marbled chunk I've stuck on my face gets peppered and made tingly by striations that take away the blue/black area's self-certainty.

✦

Art curators wear glasses like mine. Once I had a brief crush on a curator from Western Europe. I'd seen his picture in *Artforum.* I thought, "He could be in an Alain Resnais movie." (Not *Night and Fog.*) Decided I needed to "conquer" him. So I sent him a book of mine, intimately

inscribed. The inscription mentioned Theodor Adorno. This curator wore boxy dark frames and had sexy thick eyebrows some people would consider unattractive. (My eyebrows are faint, nearly invisible.)

✦

The curator with a unibrow never wrote to thank me for sending the Adorno-inscribed book. I no longer have a crush on him. But now my glasses resemble his unibrow, the unibrow that refused to cross the street to say hello or admit blood brotherhood. I can be blood brothers with my glasses instead.

✦

One of the most exciting fashion transformations in the last half-century has been the passage from *nerd* to *chic*: call it the *transvaluation of nerd*. Nerd—if transported *Star Trek*-style into another decade—becomes alluring, like a boner. *Nerd* remakes *boner* and gives us the best of the boner, without its mean edge. (*Nerd* is a softened identity, like butter left out to temper.) My glasses are boner glasses, the kind of skinny penis that doesn't frighten a first-timer.

✦

My glasses look like Mondrian paintings. Any neɪd glasses look like Mondrian paintings, and therefore like *the rediscovery of America*, as if the United States had converted from imperial entity into carbonation factory, tonic and inoffensive.

✦

Maybe my glasses (blue/black rectangles with a perverse undercover striation of nothingness sewn into their hard identity) look like a Monopoly game's Marvin Gardens and Park Place, or like the beguiling notion of lined-up hotels and houses, Chunky chocolate-bar real-estate tokens.

✦

The man glasses I'm wearing contain secret boy identity—boy playing man, boy dressed up as man, boy dressed up as *Get Smart*'s Barbara Feldon. Turn Barbara Feldon's personality into rectangles I can buy and wear. Turn Barbara Feldon's sidekick mentality—her underratedness—into a square entity, an abstraction (Alber's *Homage to the Square*) reincarnated as purchasable quiddities on my face.

✦

The glasses, two rectangles, have curvy undersides. The *outside* of the glasses looks rectangular, but when you knock on the door and enter, you discover that they are secretly circular, or contain intimations of ovals. The glasses strive toward the oval (Ovaltine) but never arrive at that milky hereafter.

✦

I feel like I'm spitting on someone's grave by writing enthusiastically about a mere object. Don't grow too attached to your glasses; someone might steal them. I left a pair on the bench outside a steam room in 1990, and when I emerged from steam the glasses were gone. I presumed someone had stolen them because he hated me, considered me intellectually or politically inferior, too big for my britches. Those Robert Marc tortoiseshells were my britches: prescription ovals, irreplaceable.

✦

And now I feel a wave of nostalgia for another pair of glasses, a pair I won't describe because they are too refined, too Eiffel Tower, too El Greco, too wiry, too Philippe Petit, too Jean Cocteau, too Alexander Calder. How can I describe my Cocteau/Calder glasses, changeable as a mobile; skittering as Kandinsky lines shooting

jizz-like into space; grounded yet airborne, like John Glenn, hand-shaken by JFK?

✦

My new glasses are not reincarnations of those Calder/ Cocteau astronaut items, whose rectangular oddity I can't describe. My current glasses—the blue/black rectangles made by Alain Mikli's son, and therefore incarnating *son*—are Carlo Ponti trustworthy emblems. But not clodhoppery. Not lame-duck. They are not like the boot of Italy, not downtrodden, not Calabrian; they are Duomo-like, if the Duomo were smashed onto its side and turned into square pellets. Two Duomo sausage patties. Brunelleschi patties.

✦

"Don't get too excited about your glasses—we may need to kill you." Who is scolding me? Some schoolyard bully? A warden who wants to scapegoat me for disseminating what I once called "fag ideation"? I spread fag ideation around like a Diptyque room spray, to conceal the "head farts" (as Antonin Artaud put it) that normative logic imposes on the trippy dreamworld of enlarged thought.

✦

When a woman suddenly wears glasses (Maria Callas at her Juilliard master classes), a newfound fox-trot cheerfulness illuminates her face. Charlotte Rampling is the female equivalent of my new glasses. She has a *sournois* demeanor. *Sournois*, my new favorite French word, means sly, underhanded. The mouth, expressing slyness, frowns to make a semicircle—a curlicue—that typifies *sournois*. Charlotte Rampling in *Life During Wartime* is the living dream of *sournoiserie*, the state of being underhanded. My glasses are *sournoiserie* practiced like the *Goldberg Variations* to become a feminine/masculine compromise.

✦

I google-imaged "Jeremy Tarian," patron saint and creator of my new frames. Turns out he is a glam-nerd doppelgänger dream: big nose, corkscrew-curly hair, thin face, only twenty-three years old, Jewish-looking, but maybe something else beyond Jewish, to spice it up. He might not be Jewish. I want the right to use *Jewish* as airborne signifier, an adjective as duty-free and pleasure-giving as *oval* or *gleaming* or *statuesque* or *ambidextrous*. Just a word, a word with a history, an adjective I can throw onto any noun. My glasses are empty, like all good nouns. My glasses aren't Jewish, but the semiotic ladder they climb (via Jeremy Tarian's corkscrew curls) leads to Jewishness as grief-free signifier.

✦

Also, I want the liberty to use the word *penis* as a mutating signifier, not as the tried-and-true motherlode of obviousness that wears us all down.

✦

Glasses, crystallizations of wish, perch on my big nose—sprained when I played Steal the Bacon in third grade and ran smack into my friend Jimmy Sims. Years later I walked into a glass door in an LA hotel near Japantown. That collision further enlarged and hardened my nose. On its fattened bridge (fatted calf?) sit my Jeremy Tarian glasses, a precious weight, bearing lightly down.

✦

I love their sleek matteness, their lack of shine when inappropriate and their sudden efflorescence when appropriate, the alternation of shine/not-shine, a polite counterpoint. The sides don't shine, but if I wiggle my head the shine emerges and then disappears. A sliced hardboiled egg's cold flatness resembles the matte sheen of my eyeglass wings, their flight toward the sectioned and the mesa-like, or toward Prague Deco furniture—not as stern as the Bauhaus, but lopped off, like most

modernist pleasures. In the spirit of Barbara Herrn-
stein Smith's phrase "the senile sublime," or of Willem
de Kooning's late paintings, let's reconceptualize mental
slowness as a form of intelligence; let's reroute lunacy to-
ward the parallelogram. Imagine what the Jetsons might
have chosen for dining-room furniture, if they'd lived in
Prague in 1922, and if their cartoon heads hadn't been
filled with Sputnik propaganda, but instead had been
programmed with Kafka.

(2014)

OF SMELLS

> . . . my mustache, which is thick, performs
> that service. If I bring my gloves or my
> handkerchief near it, the smell will stay there
> a whole day.
>
> —MONTAIGNE, "Of Smells"

I told my boyfriend, "Smell this paper." Customers came to our apartment to drop off handwritten manuscripts, which I converted, via my IBM Selectric, into present-ability. One client's pages—untyped rough drafts stank of Stilton and Sobranies. I wanted my boyfriend to smell the paper, its malodorousness a freak show. He said, "No! Please! Don't make me!" He ran away. I was behaving like Klaus Kinski in *Nosferatu*: agent of olfactory torture.

✦

Montaigne mentions hairy armpits as particularly blameworthy. Several times I've googled the connection between body hair and odor; the results are never conclusive. Crotch follicles stink, one website said. Fact? Mentioning hair makes me a stinky speaker.

✦

Blindness: I smelled it in a pine cabin where a blind flutist lived. I was her accompanist. That summer, I attempted masculinity by using Irish Spring soap. A trumpet player with hairy armpits (I idolized him) also used Irish Spring: he looked like John Davidson (costar of *The Happiest Millionaire*) crossed with Roger Federer. Throw in Franco Nero, who, in *Camelot*, had roundelay hair: a shag, songful and circular.

✦

Montaigne mentions incense. Barbara, the first girl I'd heard confess that she loved masturbating, invited me to a Buddhist temple in Berkeley, but my parents didn't approve. (I was fifteen.) Maybe LSD corrupted the temple, a cult epicenter, where I could be kidnapped. Barbara, who gave me a copy of Baba Ram Dass's *Be Here Now*, burned incense. At her Buddhist temple, I might have met men who placed sex ads in the *Berkeley Barb*, sold

outside Carol Doda's strip parlor, its va-va-voom neon twinned with beatnik espresso.

✦

Montaigne mentions perfume. I'm trying to cultivate distractibility, to fray the edges of consecutive thought. Smell is a highway for destroying punitive logic-rivets. Travel the Smell Highway to leave behind your ideas.

✦

The blindness nebula of the piney cabin, amid redwoods: the cabin's boards—if indeed they were pine—smelled flat, hard, tonic, like *The Bad Seed*. And there I arrived, with my salubrious, cheeky Irish Spring, as if with Franco Nero's Lancelot urge to triangulate, to pierce, to flash monogamy-defying curls.

✦

Incense, you were packaged in triangles, gray or umber, which slowly turned to ash. Incense, you resembled canned pet food, resistant to the human mouth. Incense, in your solid form, unburnt, you were like tropical-fish food, or doggie biscuits, or human throat lozenges (Sucrets?) that were not candy but medicine—a distinction

that my mother preached and that I still practice. Civilization depends on these rivalries. Candy versus medicine. Raw versus cooked. Men's bathrooms versus women's. The stink of a corpse versus the sweetness of perfume: Absynthe, by Christian Lacroix. I appear to be waging a holy war between perfume and death.

✦

I ran away from home—at seven years old—and sought shelter in a Safeway supermarket. I stole a roll of Certs: nourishment for the prodigal. Upon my return home, my father served me Campbell's tomato soup, which smells indelibly flat, like blindness in cabins. Tomato soup's cardboard odor doesn't tremble into a Debussy-style cloud. Certain pale reds—as they edge toward pink—are horizontal smells, like underripe members of the nightshade family.

✦

My great-aunt Alice worked as accountant at a tomato-canning factory. At a workday's end, we picked her up—in our buttermilk Rambler—from the factory. Hello to Tante Alice, as she emerges at dusk, like cigarette girls in Carmen's Seville. By the factory doorway, the tomato odor blooms in its flattest guise, as if the tin can

had communicated Martian depthlessness to the soup within.

✦

Yoplait on the tongue has the flatness of that tomato cannery's smell at workday's end: you want the flavor to ripen, but it remains unaccommodating, like a yard-duty woman I knew in first grade. Around her neck she wore a whistle, an instrument to terminate recess and to arrest malefactors. She looked like the butch secretary Jane Hathaway (played by Nancy Kulp) on *The Beverly Hillbillies.* Nancy Kulp, you were a shining force for good! Our yard-duty smelled (as Montaigne put it) "of nothing." Better to smell of nothing, Montaigne says, than to stink. I had kiddie odor, the stench of a boy exploring a supervised yard.

✦

I wonder about the texture of Montaigne's mustache. Was it straggly or thick? Odors, according to Montaigne, remained in his mustache for days. The mustache was Velcro to visiting aromas. Did the mustache proceed seamlessly into his nostril caverns, or did he enforce separation? I hope for French literature's sake that he shaved a Maginot Line between mustache and nostril.

✦

Walt Whitman: "the scent of these arm-pits aroma finer than prayer." He boldly refuses unnecessary words between "arm-pits" and "aroma." The head-on collision between "arm-pits" and "aroma"—alliterative—intensifies the blasphemous assertion of BO's sacredness.

✦

Toward what goal do I aspire, ever, but collision? Always accident, concussion, bodies butting together, "arm-pits" and "aroma" colliding. Smell amplifies collision. By collision I also mean metaphor and metonymy: operations of *slide* and *slip* and *transfuse*. I want to press my forehead against a flat surface, like a foam wall. And if the surface—whether door or page—smells like Yoplait or a tomato cannery or piney blindness or neon topless incense, so much the better.

✦

Laundry odors, though seductive, may be poisonous. I surrender to the possibly toxic perfume of Bounce sheets, those questionable yet addictive leaves tossed into the dryer to prevent unspecified damage. The most romantic moment in my childhood might have occurred

during a Cub Scouts camping trip, when I brought a towel and soap to an alpine creek for morning ablutions. My mother had packed the towel in my rucksack: maternally laundered towel, aroma finer than Ruby Keeler's return to the Broadway stage, "Take a Little One-Step" her anthem.

✦

My pal in fourth grade had stinky feet, I discovered when sleeping over at his house. Maybe he bragged, "I have stinky feet," and suggested that I smell them to verify; or else I came to this conclusion myself, and taunted him with the verdict. His feet were large, as were his cheekbones; our mutual competitiveness was large, as were our growing stamp collections Doggishness suffused his feet, though he didn't own a dog. The concept of "another boy's house" came with "dog" built into it, and therefore "turd." Onto the feet of a young Christian descends (in my Jewish brain) an abject avalanche. Twice, we fell into foreplay. Our erotic incidents took place in a bathroom and involved a cup and a rug. Did I insert my penis in the cup? Did I command him to lie on the rug? Did he sprinkle talcum powder on his rank feet? Was I the ringleader? Did I have a plan? Was I inspired by *And God Created Woman* on Channel 36, a UHF frequency from distant Stockton? Did our foreplay

interrupt tournaments of Battleship and Clue and other board games, like landscape-feigning jigsaw puzzles overlaid with Kissinger-style statecraft-in-utero?

✦

Smell is syntax, is grammar, is the copula, the "is," the copulating verb, the intercourse sign of =, the stink of equivalence, the stink of enforced likeness and its pleasures, whether fecal or ambrosial. Anywhere I go with smell (and we can go *everywhere* with smell) I owe to the permissive powers of the copula, the "is," the stick-shift-in-neutral power of olfactory suggestiveness. We could therefore call smell "the whore of grammar." Or "the fall into false closure." Or "the rapid departure into cloud consciousness." Or "a sudden dilapidation." Smell locks us into words but also helps us to escape them.

———————

Annex: What I Took from Montaigne

From Montaigne, I took hairy armpits. I took mustache. I took the desire *to smell of nothing.* I took perfume, incense, seasoning, gender. I took brevity. I took casualness. I took a tourist's tone. I took sex. Sex I can take from anywhere; I don't need Montaigne for sex. But I'm

glad to find it in his sentences. From Montaigne, I took
disgust: sex's doppelgänger. From Montaigne, I took ran-
domness and decisiveness. I took easy movement. I took
permissiveness toward *in medias res*. We enter an idea in its
middle. We leave before the idea can reach completion.
We lean into the idea from above or below. We don't
greet the idea directly. Ten cents a dance with the idea.
Toward the idea we express reverence but also eventually
dismissiveness. We don't allow the idea to tire us, and we
try not to ruin the idea by pressing too hard against its
vulnerable surface.

(2013)

GAME OF PEARLS

I.

"Game of pearls," my teacher said. "Play the notes like a game of pearls. That's the well-known term for the sound you want. *Jeu perlé.*"

My ideal piano moment is after dinner: a few glasses of wine, and then some easy Chopin mazurkas (with soft pedal to protect the neighbors). I call these inebriated experiences *the end of time*.

2.

My Mason and Hamlin baby grand is a minor angel of devastation: against the apartment's eventless hush (punctuated now by a police siren), the instrument asserts the percussive clamor of a Rachmaninoff prelude. Its opening passage makes no sense to me; it reminds me of a loud, public cough, without a touch of the lachrymose, only of the interruptive and the contagious. I can't master the coughing phrase, but I like to impose it on my living room, to hurl it against the white walls as

an aggression or a proposition: *take me up on it!* The passage also reminds me of cranking an old-fashioned ice cream churner, its inner chamber surrounded by rock salt.

3.

Playing the piano is a supremely lazy occupation, and yet it mimics a dutiful form of mechanical diligence—a chore, like mowing the lawn, folding laundry, counting pennies, or typing a form letter someone else has composed. When I play the piano, I am doing nothing, but I am also working—a treadmill, a task never completed, like writing in a diary whose pages I burn after finishing them.

4.

Later I will systemize my impossible subject, but for the moment I want to enjoy a tentative movement between its different chambers. I am not certain which are important and which are extraneous. Nor am I certain whether this topic is one that I have the strength to pursue.

Just as every piece I play has already been played by someone else, every fragment I write in this essay is something I have already written. I have been secretly composing (or avoiding) this meditation for over twenty years. Long pauses frame its tentative articulation.

5

I have a French sound. That's what I choose to remember a teacher saying. Perhaps he said, "You have a sophisticated sound." I don't drop my weight naturally to the bottom of the key. Instead, afraid of uncontrolled deposits, I suspend weight in my elbow.

6.

In an unsettled 1933 performance of the first Chopin prelude, recorded by Alfred Cortot, a Frenchman who later became a collaborator with his country's occupying enemy, he moves forward in agitated waves but then backtracks, self-consciously retracting his rash upheavals.

Looking at my score of the preludes, I find a few handwritten notations. Above the opening phrase of the "Raindrop" Prelude, twenty-seven years ago, my teacher wrote in red pencil one simple, enigmatic word: "tone." She meant: make a pleasant, rounded, singing sound. Toward the end of the fourth measure of another prelude, she drew an arrow in red pencil and wrote, "don't stop." I still have a deplorable tendency to arrest phrases before they are completed.

At the top of the next page, my teacher wrote, in black pencil, "weight transfer"—one of her favorite terms, and one of her most mysterious. It meant: don't attack each note of the melody separately, but distribute the hand's gravity evenly from finger to finger.

7.

If I were to play the piano now instead of continuing to write this essay, I would begin with scales, up and down the keyboard, four octaves. Today my fingers might be in the mood for F-sharp major, and then for F-sharp minor. F-sharp minor sounds harder than it is.

Next, arpeggios. My lazy thumbs hesitate to tuck under, and I'm no good at rotation.

After warming up, I'll make a cup of tea and stare out the window at the gas station, or, because my hands are cold (on the verge of hysterical immobility?), I'll immerse them in hot water, à la Glenn Gould.

I, too, have a command of things contrapuntal, though my counterpoint is psychological—one thought pushing against another, interfering, cooperating.

Fugal subject: *should I play the piano or do something constructive with my life?*

I step into fog when I play. I begin with a clear intent: let's attempt the Paul Bowles sonatina! And within fifteen minutes the familiar haze descends.

8.

Occasionally I intend my writing to be comic—to offset the melancholy, and to mute the maledictions. Unfortunately, there is little humor in this essay—unless we step back from the voice of its narrator, and imagine him as a

character, a foolish, fearful, adamant man, gripped by a misconception.

I demand wisdom from my fingers: at least they must sound human, and not like spoons and forks! The piano, however, is not a human being. It lies halfway between a friend and a rock. More responsive than a rock. More predictable than a friend.

9.

At the moment I am preoccupied with two discords in "Corcovado," a tranquil dance from Darius Milhaud's technically undemanding suite, *Saudades do Brasil*. In the opening measure, a G in the left hand meets the piquant interference of an F-sharp in the right hand; and in the next measure, a C-sharp in the right hand, passing quickly, confronts a D in the left hand. These dissonances don't linger long enough to sound provocative, negative, or rabble-rousing, but they make my fingers complicit with a tiny revolution in taste.

10.

I should suddenly talk about sex in order to draw the reader's attention elsewhere, just as my attention is always distracted—by the view out the window, by the fantasy I forgot to describe, by the thought in front of the thought I am in the midst of trying to explain.

11.

Here is a miniature novel.

After suffering a memory lapse and nervous break-down, Rosanna Duvette, an American debutante, travels to Sicily to recover. There she finds a ground-floor apartment in quaint Noto, and rents an upright. At lunch she sits beneath a lemon tree and broods about her wealthy parents. An American artist is also living in Noto. "Frances Churchweather" is his alias. Later she discovers his real name is Francesco. He wears a bead necklace, and has muscular, hairy legs. He tells her, when they are lying in bed, "See these soccer-playing thighs? I come by them naturally, from my dead father."

12.

In the future I may write an essay on the tradition of the piano morceau? Especially about how my mind drifts while I play waltzes? Perhaps also an essay on the madness and pleasure of two-part inventions?

Soon I plan to venture into bitonality: two keys at once, superimposed, no attempt at reconciliation.

All my efforts to make sense of bitonality are doomed by my ignorance of tonality's rules. What are the principles of voice leading? I can't remember what a "dominant" is, though once I studiously marked up the score of an early Beethoven sonata with the appropriate symbols

for modulations and tonal relations. Another time, as if under heavy sedation, I made inscrutable structural notes on the first movement of a Schubert quartet—"Death and the Maiden."

13.

Pretend I work in an edge-of-town bordello as a "mood" pianist entertaining customers with Chopin waltzes as they wait for their ladies. No strain, no bravura: my technique, careless and "musical" (my first piano teacher's highest term of approbation, though it is redundant to call a musician "musical"), smuggles into my apartment an imaginary atmosphere of prostitution, the floppy comfortable bodies of bawds and johns.

Satie wrote "furniture music." Everything I play becomes, in my slack hands, "apartment music": hedonism, hookahs, harlots, the bliss of being a transvestite on the brink of unconsciousness, adrift on out-of-tune album leaves.

Playing the piano for myself, in an apartment, in a tumultuous city, where there are so many more fashionable and productive things to do, proves that I am *sliding downhill*, and feels like gently but decisively biting human flesh.

The keys go down three-eighths of an inch. That's not much. A true pianist would say: *the ecstasies*. Untrue pianist, I'll say, instead: *the ambiguities*.

14.

Why can't I manage, ever, to sit alone, slightly drunk, in churches, listening obediently to claviers? Maybe I should become a Quaker. Quakers believe in silence. Perhaps I should devote time to "green" causes.

15.

Some favorite piano records, from youth:

Best beloved was a live recording of Vladimir Horowitz's return to Carnegie Hall after twelve years without performing. (Some critics considered him neurasthenic.) I limited myself to half of the four-sided affair: I listened to the Bach-Busoni Toccata in C (side one) and the Schumann Fantasy (side two), but I ignored the Scriabin "Black Mass" Sonata (side three) and Chopin's G minor Ballade (side four). I esteemed the way Horowitz teased inner voices away from their ordinary bourgeois surroundings, and the way he tended to play notes not simultaneously: he broke and staggered them, deliberately tripping them up, or spreading them into a peacock-feather fan.

Second beloved was Dame Myra Hess's recording of *Symphonic Etudes* by Schumann, who tried to drown himself in the Rhine: certain notes evaporated the moment she played them. I admired her humility: she knew how to subordinate her artistry to besieged wartime England, and to muteness.

Third beloved was the last B-flat major Mozart So
nata, recorded soon after World War II by Artur Schna-
bel, famous, in my eyes, for his warm-toned perfectionism:
the disappearance of some notes signaled a decorousness
beyond the pale, as well as a hyper-showmanship, the vir-
tuosity of diminuendo-unto-nothing. That has always
been my unreachable ambition: to show off moments of
diminishment, to prove to a rapt audience that I, too,
know how to curve backward into emptiness.

Fourth beloved was Rudolf Serkin's recording of
the knotty Brahms D minor Concerto. (Serkin him-
self meant little to me: he was merely the vehicle for
Brahms.) I revered the chunkiness of the chords, each
resting on what seemed the wrong foundation (the sixth,
rather than the tonic?). When I first heard the trills at
the beginning, I thought, "Ugly." They sounded like
unmitigated, antisocial racket. Then I listened to these
tremolos a few more times, and found them, eventually,
beautiful.

Fifth beloved was Arturo Benedetti Michelangeli's
performance of Chopin's B-flat minor Scherzo. (Here is
what the liner notes say of Mr. Michelangeli: "His own
personality is so perfectly expressed in his piano playing
that his private life outside music, together with any some-
what bizarre or puzzling features which might be known
or alleged to mark it, seems completely unimportant.")
I worshipped his flirtation with disappearance—in the

soft passages, the melody stood out, appropriately, while harmonic filigree fell back into one undifferentiated sea. Slavishly, this background forgave the tune its arrogant impositions. I appreciated servile accompaniment, a left hand that minded its own business.

16.

I plan to compile a useless roster of every piece I have ever performed, in however humble, juvenile, and unprofessional a venue. This list will be very brief.

Another futile list I hope to compose is all the chamber music I have performed or attempted: this list will be even briefer.

A final list will include every word I've written—or that a teacher has inscribed—in every musical score I own. I will annotate—gloss—each enigmatic indication.

However, I don't want to be Blanche DuBois, praising a phantom, bygone Belle Reve. Harboring few illusions about my piano past, I care exclusively about this current life of desultory, incremental practicing toward no goal.

17.

Of course I may be exaggerating my affection for this reclusive activity. For twelve years, a period of willful abstinence, I stopped playing. Piano disappeared. Eventually it may disappear again.

18.

Poets disappear: Arthur Rimbaud stopped writing poetry when he was nineteen, and his disappearance is an important part of his extant work. Silence provides a resonance chamber for the lyrics that preceded his defection from words. According to critic Wallace Fowlie, after Rimbaud quit poetry, he "enlisted in the Dutch army," "deserted," "worked for a while on the island of Cyprus," "worked for an export company, dealing principally in coffee," and "sold guns to King Menelik of Choa."

Soon it will be evening, and I will allow myself to stop writing and to approach the piano. First I will do scales. Then, a wordless *Poème* (1913) by the underrated Russian mystic composer Scriabin, who, soon after composing it, died of an infected boil on his upper lip. This piece is marked *en rêvant, avec une grande douceur.* dreaming, with a grand sweetness.

In my hands, the piano is a grave occupation: without jokes, without sexuality.

19.

While playing, I silently give myself musical advice, with the intensity of a pharmacist describing side effects. A recent, wordless, internal lecture concerned the importance of correct rhythm. I decided I didn't need to inject expressivity into the piece; my duty was simply to

count the beats and to keep the polyrhythms (five against three) in perfect order.

I don't listen to these lectures, and I never write them down for further consideration, so today's adages disappear by nightfall, and tomorrow I must begin again, trying to figure out, from scratch, how to play.

20.

Last night I dreamt that a former teacher, an important critic, asked me what I wanted to write about. I hemmed and hawed: I wanted to say, "Nothing!" But I needed to come up with a respectable answer. So I said, "Genre and utopia." I knew this was hot air. But I also meant it. The teacher scoffed: "Genre and utopia? Some people shouldn't be allowed!"

21.

A music teacher once told me that I occasionally revealed a sophisticated attention to details but that my basics were bizarrely out of place. Fact: the one time I performed the Chopin G minor Ballade, in a difficult passage my left hand simply stopped for a measure. Confused, the fingers retreated, gave up. A decent pianist would never skip four beats of the bass, impoverishing the harmony, leaving the right hand alone with its contextless declaration.

22.

Playing a piece for a listener, I race toward the finish line, panting, out of breath, as if unattractively flailing my arms. No time to notice beauties, or to observe simple rules of musical prosody: enunciation dissolves in a flurry of missed notes, punched-out figures, rushed gestures.

Problem: when the piano suddenly seems too loud, I clumsily resort to the soft pedal, as insurance against impoliteness.

The few times I've heard a tape of myself performing, I've been horrified—more so than when catching my bespectacled reflection in a shop window.

"I play" is one of the working hypotheses undergirding my existence. That supposition, however, is hobbled by an unfortunate adverb: "I play *badly*."

The pathetic, too, demands anatomization; failure is as genuine a subject as success. Playing *pathetically* interests me as much as playing well.

23.

If in a few years I come down with arthritis or another crippling hand disease, then I will look back at this present time, this period of grousing about my mediocrity, as an opportunity squandered: "All those years he had a fully functional physical mechanism, and he did nothing but complain!"

As a teenager I had a crush on Misha Dichter, a handsome Shanghai-born Jewish pianist with a shock of dark hair, like a delinquent in a '50s "social problem" film. (*Dichter* is German for "poet.") As I saw him play the first Liszt concerto's final octaves, he half-stood, hovering, raising his butt a few inches above the bench, strength moving from his shoulders down to the keys. This feat impressed me: rising gave him immeasurable power to state an ending.

(2001)

CORPSE POSE

I have corpse envy. At the end of yoga class we do corpse pose, savasana: dress rehearsal for the morgue. I'd planned to write an essay about how literature should start enjoying its own corpse mode, its oft-foretold senescence; I'd planned to become an expert on corpse pose, to analyze what I feel lying on a blue yoga mat, waiting for the bell to ring, savoring my slack-jawed simulation of interment. I'd planned to divagate on corpse pose's relevance to contemporary literary practice, but then, yesterday at noon, my stepfather died. What if the chaos surrounding my stepfather's corpse—figuring out funeral arrangements or letting my older brother handle them while I stand idle—ruins the essay I've promised to deliver? I've sworn to write a piece entitled "Corpse Pose," but now I must fly to California to deal with a real corpse.

✦

I could write "Corpse Pose" on the airplane, en route to California for the funeral. But maybe I'll be too

discombobulated. On a plane, I can't spread out my notes. While I paint, in my studio, I jot down notes on lined yellow 5-by-7-inch pads. My painting notes aren't literature, though I save them in a manila folder as if they were valued drafts. I could transcribe them and reincarnate them as a poem or an essay, but I dread that process. Transforming the notes into literature will involve making Sisyphean prosodic decisions. Should I mutate the fragments and phrase-clusters into sentences? Should I stack up the sentences paratactically, or integrate them into coherent paragraphs? I might decide that the notes are actually a poem; lyric identity helps me avoid syntactic maturity.

✦

Here are five of my painting notes. If you want to help me sculpt them into literature, be my guest.

> (1) *Add white to black edges to cover up the blue.*
> (2) *Change color of lozenge behind butt.*
> (3) *Lavender heavens deepen Joan's body.*
> (4) *Cover the ultramarine area with Twombly-esque graphisms, using small brush.*
> (5) *Use palette knife. No outlines until I see forms in the smudge.*

These notes won't be literature until I shape, frame, or contextualize their stammering.

✦

Contextualize: that was what I learned in grad school, a PhD program, not theory-heavy. Contextualize. That meant history. Find the historical context for my close reading of butt-fucking imagery in H. Rider Haggard's novel *She*. The context that interested me wasn't history. The context was my desire to find butt-fucking imagery in H. Rider Haggard's *She*, and to stimulate my class of fellow grad students by audaciously leading them through my sodomitic interpretation.

✦

In my stepfather's presence I never referred to him as "stepfather." Perhaps this omission distressed him. One year, for Christmas, I gave him a copy of *The Arcades Project*, an assemblage of notes, a book difficult to read but easy to idealize. I had fallen in love with Walter Benjamin's numinous incompleteness, and wanted to present this ruin to every man or woman I knew who needed fixing, who needed to be made more monumental. My real father (my mother's *first* husband) was born in Berlin, 1928; *father* and *Germanic* are twinned concepts. I

thought I could firm up my non-Germanic stepfather by giving him The Arcades Project. Or maybe I wanted to make him a bit more ruined.

✦

My stepfather, a historian, knew how to find contexts for random information; his specialty was the Second World War, and so he could divine a context for The Arcades Project. Amelioration, idealization, repair, and obfuscation are the indirect aims of most of the gift-giving I've done in my not particularly generous life. I've given my real father Georg Christoph Lichtenberg's The Waste Books, Benjamin's Reflections (containing "A Berlin Chronicle"), and a CD of Schumann's Der Rose Pilgerfahrt (The Pilgrimage of the Rose). Here are prerequisites for a gift to a father. (1) It must be German. (2) It must be fragmented. (3) It must be lionized only posthumously. (4) It must represent ruin. (5) It must do a good job of transfiguring ruin.

✦

To the first session of a semester-long seminar I taught on The Arcades Project, I brought two personal relics of dubitable relevance: a 1968 Kodak Super 8 movie camera, and a photo of my great-uncle Walter, a chemist, who died in Caracas in 1956. Born in Berlin, he looked uncannily like

Walter Benjamin; judging by my great-uncle's face in the photograph, I could imagine that he'd died of overthinking. The photo, though it served no legitimate pedagogic function, encapsulated my infatuation with *The Arcades Project*, whose incompleteness held my lacunae in a loving, unparaphrasable grip. Because I, like my uncle Walter, resembled someone liable to die from overthinking, then perhaps I could be trusted as a living representative of Benjamin's auratic incompletion.

✦

But why the movie camera? I brought to that first *Arcades Project* class my Super 8 movie camera to embody the aura of outmoded technologies. This scuffed object a pathetic, nonmonumental bit of American midcentury flotsam—hurtled me back to photoreproductive cross-roads, the fork in the road separating Swann's way from the Guermantes way. I now display this talismanic camera in my apartment's hallway; next to the camera, on a diminutive shelf, are ten back issues of *BUTT* magazine, a Ballantine 1961 paperback screenplay of Fellini's *La Dolce Vita*, and a stack of yellowed books I bought in Berlin, including Benjamin's *Berliner Kindheit um Neunzenhundert* (*Berlin Childhood around 1900*) and a 1914 edition of Richard Dehmel's *Hundert Ausgewählte Gedichte* (*100 Selected Poems*). Dehmel wrote the text that inspired Schoenberg's

Verklärte Nacht. Transfigured Night, like my 1968 Kodak Instamatic, was a bygone innovation I still hadn't adequately studied, an outmoded iconoclasm still waiting, over a century later, to wake me up.

✦

Also on this shelf, beside the Super 8 camera, sits a five-inch-tall porcelain replica of a toilet, my household's half-assed homage to Marcel Duchamp's *Fountain*, another outmoded yet still detonating innovation. Inside the tiny toilet's bowl, a transparent glass marble dumbly rests (an instrument of divination, like the fortune tellers Benjamin finds in the arcades); and in the toilet's chassis, where its plumbing should be, resides a bundle of 2-by-3½-inch cards—a handmade, nondenominational tarot deck, a gift from Eve Kosofsky Sedgwick, who decorated them with rubber-stamped images of Proust, various bodhisattvas, a Virgin Mary, and other divinities.

✦

One night, my mother accidentally spilled sugar on the kitchen floor and told my stepfather to sweep it up. She called out for him: "Sugar Boss!" (Henceforth, in my private lexicon, "Sugar Boss" became his nickname.) Already stooped from Parkinson's, he stooped even more

to clean up the sugar, whether with a whisk broom or a wet paper towel. He could be boss of sugar, but he could not be boss of my mother's life, her body, or even of his own body, over whose movements he had less and less control. Sugar Boss was sweet, passive, easily trampled, easily ignored, almost speechless. Sugar Boss, now a corpse, posed for me, during the last decade of his life, a nosological dilemma: was Parkinson's the sole cause of his shocked, masochistic inanition, or did Parkinson's continue a process already in motion?

✦

My aim, originally, in this essay, before Sugar Boss became a corpse, was to write about a kind of literature that follows in the wake of Samuel Beckett, Thomas Bernhard, Joe Brainard, and more recent models—a literature that makes no bones about its corpse-like exhaustion and that recycles its depletion (its stance of no longer caring about literature) into a new, faux vitality, a vitalism composed of ellipses, blunt honesties, paratactical leaps, silent sulking fits, and a staged love affair with its own posthumousness. If literature's foundation—what I've recently called "the jejune sequentiality" of onward-proceeding speech—has decayed, and we are now writing with invisible ink, could we learn to savor invisibility, and turn this deficit into a new source of energy? (Recurrent

bad dream: in a taxi, I'm writing a poem or essay, but the ink turns out to be invisible.) Before Sugar Boss became a corpse, I'd hoped to issue a hortatory call for texts that might take blissful advantage of literature's posthumousness and enjoy their deadness. I wanted to wake up my own language (or put it to sleep?) with a call perhaps anachronistically and credulously avant-garde; to start writing with more parsimony and less passion; to exhort myself to be cold, meager, scant, illegible, inaudible, and to find in that bleak zone a new repose, the repose of corpse pose; to play dead, in prose, before my time, thereby magically evading actual termination, like Scheherazade with her stories.

✦

My new idée fixe is asemic writing—writing that doesn't use words or signs. (Classic examples are the drawings of Henri Michaux, author of *Miserable Miracle*, a mescaline journal in the spirit of Benjamin's hashish investigations.) I'd love to pontificate on behalf of asemic writing—to give you asemic assignments—but I'm distracted by a graveyard in California, Home of Peace Cemetery, where, tomorrow, or soon thereafter, with or without my presence, my stepfather's corpse will be interred in a small plot of land. Another family member is also buried there—my mother and father's first child, a

stillborn boy, nameless, delivered on February 17, 1955. This stillborn baby who remains a focus of my mother's ruminations—demotes me from my perch as second son. In fact, I am the third son, if we count the first child, who had no out-of-womb existence except as corpse.

✦

My mother, who suffered a stroke a few years ago, can speak cogently, but she has difficulty reading and writing; she sometimes write words, or groups of letters recogniz-able as words, though she is mostly unable to decipher them. Now she regards literature as a region from which she has been unfairly barred; and in this twilight world, largely without literature, except for the occasional au-diobook, except for *Moby-Dick* and poems of Emily Dick-inson and a few other CDs she plays without apparent pleasure, she engages in eddying rumination. My older brother, who is a cellist but in another life might have chosen to be an airplane pilot or a psychoanalyst, calls it "perseveration." One subject on which she perseverates, as if making a poem out of thought itself, is the stillborn first child. (Earlier this year, with a rabbi, my mother planned a magical scheme. For a fee of $500, the rabbi offered to perform a ceremony to reclaim the stillborn child's soul.) The great romances of my mother's life have been with the disappeared, the out-of-reach, the forfeited;

the stillborn child possesses an irrevocable reality and po-
tential that we four surviving children lack. But now I'm
stuck in the cul-de-sac of autobiographical recitation; I
need a good dose of asemic writing to wake me up.

✦

I'd promised myself to end this essay with a guidebook
on how to "go asemic"—how to deterritorialize literature,
how to enfranchise the hand, or mouth, or mind—but
the only suggestion I can think of is to urge you to find
an old bathrobe, shirt, skirt, or towel, to lay it on the floor,
and to write on it, perhaps with oil sticks, pastel crayons,
markers, charcoal, graphite, or pen and ink; then, if you
like, you could affix this item of former usefulness—now
serving as papyrus—to a wall, with ordinary pushpins,
and enjoy the spectacle.

✦

The stillborn child my mother delivered on February 17,
1955, is only theoretically my sibling. The stillborn child
is my mother's preoccupation, her pet corpse, her phi-
losopher's stone, her pact with the unfinished and the
unfinishable; he is her grudge, and we are together a tap-
estry of grudges, intricate as a codex Bible. (She recently
contemplated belated legal action against the hospital

or doctor connected to that 1955 stillbirth.) Like my
mother, I covet the unconsummated, the never-arrived;
as in Delmore Schwartz's story "In Dreams Begin Re-
sponsibilities," I pose as an Orphean voyeur who wants
to turn back time to arrest an unfortunate or desired cat-
aclysm at the instant *before* its fatal commencement.

✦

I was ushered into the realm of literature at an early age.
When my mother took me to kindergarten the first day,
she told the teacher, "Wayne's a reader." (I've mentioned
this incident, a decade ago, in a long poem; repeating the
story now is a self-cannibalizing act that leaves an after-
taste of shame.) I knew at the time that my mother was
lying, exaggerating, or speaking her own wish. I wasn't a
reader, not yet; I could only eavesdrop and finger-paint.
Any good fortune I've had, as someone granted a privi-
leged and seemingly unhindered relation to literacy and
to literature, I owe to the stillborn child, for if he'd sur-
vived his birth (I recall learning that he'd been stran-
gled by the umbilical cord), I'd be the third son, not the
second; in my life-as-fable, only my mother's *second son* is
the child destined to have a felicitous and unencumbered
relation to literature.

✦

Does my relation to literature seem unencumbered? Do I seem a serene-tempered representative of literature's pleasures, rather than its ordeals, curfews, and solitary confinements? Where did you get the idea that anyone's relation to literature could come without fleshly exactions? When I write, I'm on the verge of physically exploding. Hands sweating, I'm hunched over, poised to attack or defend, like a raptor or a cowering dog. Language compels me to sweat, slaver, tremble, squeeze. My body is a bloody washcloth I'm systematically wringing. Sentences demand aviation: adrenaline and anxiety provide horsepower for my freakish, impossible flight. Caught in a schizogenic double bind, I use language to flee language. To write, I must burn imagination's mansion to the ground, like Rochester's Thornfield in *Jane Eyre*. The guilt and depletion I feel *after* writing is an arsonist's hangover of remorse—an arsonist who knows that he has destroyed the last house on earth, or the last house that his paltry book of matches has the power to destroy.

✦

Is masochism the only gate into literature? I'll end on a more cheerful, less self-flagellating note: here, as promised, are assignments for attempting a practice of asemic writing, the only closure—the only paradise—I can propose.

✦

Write a few phrases, without premeditation, on a large surface. Use ink, acrylic paint, tempera, or any other wet medium. Then, take another surface, the same size, and press the two surfaces together, strongly enough to make an imprint. Separate the surfaces; observe the irregular, unscripted patterns that the original phrases imprinted upon the receiving membrane. Reorganize these islets and puddles into new shapes, not necessarily into letters or words. Or else form new words based on the puddles. We'll call this sheet *the puddle surface.*

✦

If you are not satisfied with your puddle surface, repeat the process by writing, on a fresh surface, some new phrases, without premeditation, this time using a different color ink or paint than you'd used in the previous experiment. Then, press the newly inscribed surface onto your earlier puddle surface. Separate the two surfaces, and examine again your now-transfigured puddle surface. Doctor it, judiciously and quickly, by using a rag, paper towel, or piece of cardboard.

✦

Place random strips of nonstick masking tape—known as "artist's tape"—on a large surface, whether paper, canvas, wood, cardboard, or whatever is easily obtained. Then, take a pastel crayon, or any other marker that makes a strong impression, and quickly write some phrases or sentences on the tape. Let your markings exceed the tape's edges and impinge on the surrounding surface. Carefully peel off the masking tape. (You may discard the tape, or you may use it, later, for new experiments.) Observe, on the now untaped surface, what remains of the words you originally wrote. Using a different color marker or crayon, play with the areas formerly covered with tape. Don't feel obliged to reform the asemic traces into words.

✦

Using a liquid medium, copy a preexisting text (for example, a paragraph from the newspaper or from an email) on a spacious surface. Spend no more than five or ten minutes copying. Then, impress this surface onto another surface, of equivalent size. Separate the surfaces; observe the results. (Your focus will be, I imagine, not on the original surface, which functions as a photographic negative, but on the second, imprinted sheet, the so-called puddle surface.) Now, using any medium, wet or dry, begin to improvise upon this puddle surface.

✦

Apply black gesso to a piece of wood. Let dry. Then, with a white pencil, start writing or scrawling on the primed wood. If you are not pleased with the results, cover or circle the parts you don't like with an opaque liquid medium—say, cobalt blue Flashe vinyl paint.

✦

In the trash, or on the street, find some refuse elements that seem likely surfaces for your marks. Take these surfaces home, and apply black gesso to them. Let dry. Then, with a strong opaque color—red, green, lavender, pink— in whatever liquid medium you like, with finger, brush, popsicle stick, Q tip, or any implement you desire, begin to write something very unimportant, something so trivial you would never impose it on a reader. When you lose interest, stop writing words, and let your hand move freely, and with whatever impulse strikes it, across the surface. If you don't like the results of this scrawl, speed up the process, and move your hand more frenetically. If necessary, begin humming, mumbling, singing, cursing, or shouting, while moving your hand.

(2013)

BEAUTY PARLOR AT HOTEL DADA

Toronto, Steam Works, impulse: man in sling.

Today, read Marguerite Duras, *Lol Stein*.

Maybe I should spend a telltale year typing up excerpts from my journals.

Finished reading Peter Handke's Thucydides reflections, short taut book.

Downloaded Jacques Lacan's essay on Duras (in French).

Guy downstairs doing his perpetual spanking act, with the counterpoint of a dog's barking.

Saw, at galleries: Basquiat text paintings (Cheim and Read); John Tremblay paintings and Wayne Gonzales paintings (Paula Cooper); Betty Tompkins (FUCK paintings) at Mitchell Algus; Matt Connor's debut show at Jeff Bailey.

Dream: told a fiction writer (Tom Perrotta?) that I was working on *Three Torsos*—three truncated fictions.

Malcolm Gladwell sitting next to us at this café.

Tomorrow (Father's Day) write about all the opera tunes I played manically tonight and how their libidinal sur-feit made it impossible for me to concentrate on Cioran's *Tears and Saints*.

Fiddlehead ferns, intended for dinner, were rotten. They smelled (Steve said) "like a horse stable."

Dream: in a dark room I put John Ashbery's hand (not unwilling but passive) on my cock and made him give me a hand job.

K.'s chest hair, thickly encrusted, like a pizza's charred bottom.

White butterflies (moths?) enjoying each other's pres-ence and also the proximity of hyssop.

Dream: slept in President Bush's bed at the White House. Discovered he did yoga every morning, by himself.

Sad not to be Greta Garbo. Sad not to be more experimental.

In love with Zuco 103, rock band, Amsterdam/Brazil.

Book idea: *Beauty Parlor at Hotel Dada.*

———————

Tanned guy who looked like a damaged Andalusian Bruce Springsteen, gap-toothed, watching a soccer game; a frizzy-haired woman who looked like Helen of Troy; at another table, Lenny from *Of Mice and Men*; and a more educated male companion, distantly Jewish, wearing silver wire-rims and eating yellow rice.

The sound of this convent room's window closing is like a cry of pain or irritation—a noise that someone with very long hair might make.

I cope with boredom by scanning his body for erotic potential: small butt, in proper gray slacks.

Dreamt last night that I didn't give my address to Paul Newman, even though he was interested in me. He said that Joanne Woodward hadn't paid attention to me

until I said "It's necessary to blow up your idiosyncrasies" (meaning *exaggerate* or *amplify* your oddness).

Started reading a book about blind blues singers. Wrote down eleven French words I didn't know.

Dream: I tried (energetically) to explain to my mother the gay scene in Berlin.

Small amounts of wind are disturbing or enlivening the remnant plants (weeds? corpses?) in our garden.

Dream: buying wine with Eve Sedgwick—a meager selection at the wine shop, which was either in Brookline, Brooklyn, or the West Village (the Gold Coast).

———————————

I didn't buy a blue down jacket because it was a woman's size—and therefore the shoulders were too tight.

Long ago, sitting behind Ashbery and Koch at a fussy organization's poetry reading, I noticed the tension in Koch's neck.

Drinking jasmine tea and wearing my clumpy fag-butch retro-monster patent-leather construction boots.

Dreamt I met my father in Vienna or Prague. We ate at a pancake shop.

Listened to Dietrich Fischer-Dieskau singing Schubert; Anna Moffo (I swear it's her very first recording) singing "Là ci darem la mano" (probably from 1956's Aix-en-Provence festival); Teresa Stich-Randall singing "Porgi amor" and "Dove sono" (applause after "Dove sono" suggests to me that the performance is also from 1956 Aix-en-Provence); Jan Peerce singing the Passover scene from *La Juive*; Robert Merrill and Dorothy Kirsten singing the death of Thaïs; Mary Garden singing "Depuis le jour"; Renata Tebaldi singing arias from *Turandot, Manon Lescaut,* and *Butterfly.* (Which proves: the past has been unfairly abandoned.)

Listened also to Michèle Morgan (in French) reading children's stories.

He rubbed my feet while I read Borges. Borges bores me. That confession seems heretical.

A soccer player said something sweetly conspiratorial about my orange-and-red sneakers.

He smelled of cigarettes. I was shaving at the sink, and he was drying his hair and body with the automatic dryer.

Started to watch *Manon 70*, starring Catherine Deneuve, made in '68, when '70 was the Ungaro-clad future.

Want to read David's anthology of essays that hover around the topic of public sex.

She said, about my bare legs (I was wearing mid-calf pants), "They're green."

Dream: my right hand and right shoulder (right, not night) froze as I tried to play my Fauré impromptu for a piano teacher—an old master, wearing just a jock strap. He was part of a louche gay couple, pale and hairless. In Lamont Library a man was mopping the floor of a toilet stall. A guy named Lucky Bastard was applying for admission to CUNY or Princeton. C. stood up in the audience (she was volunteering for the admissions committee at Princeton), but she "spotted" her leotard with urine (pregnancy incontinence) and quickly sat down again.

On Beniamino Gigli I feel a crush developing. I listen for his idiosyncrasies. Are they glottal peculiarities, or perversities of attack?

Gilles Deleuze suggests that remembering and repeating are not absolutely opposites.

Individual sentences may be choppy and sometimes re-petitive, but through accumulation, the whole acquires a strange momentum and inevitability—even amid the deadness.

I want to minimize the self-flagellation without omit-ting it altogether.

Discipline myself in the near future to write another hypersexed novel in notebooks—a pornographic fantasy.

My neck looked saggy and old tonight.

This notebook's tight pages encourage ellipsis and abbreviation.

I will not exterminate the book.

Bumped into Massimo Audiello, who said that Dun-can Smith's unpublished *chef d'oeuvre* was a long semiotic blow-by-blow analysis of the film *Sunset Boulevard*.

Maybe Yves Sharp's twin is a movie star, or Yves Sharp is convinced that this star is his twin, but the star won't acknowledge the twinship.

Clearly it's fictional, because Yves Sharp doesn't exist and therefore Caroline Kennedy couldn't write him an email, mentioning her decision *not* to run for Senate . . .

Retitle *Suicide Essay*. Call it *Fassinder and Plath: A Novel*.

This morning's handsome cab driver: I orally noted his short-sleeve shirt, and watched his ears lit by sun. Searched for outline (and found it) of tiny hairs.

Now, reading Bernadette Mayer's *Poetry State Forest*, I regret being ruthless toward my construction-paper poems.

My mother said I saw an audiologist when I was three years old, because I stuttered.

Saw T. (of the long dick) on the street. I was wearing a red bow tie.

Nickolaus is making portraits of anuses. Maybe I'll volunteer.

My Joe Brainard drawing easily gets crooked.

Title: "Tippi Hedren and the Three Bears."

Add something clarifying about Harpo's relation to homosexuality—and, particularly, about my wish to see straight men queered.

My father described Tom's gift—or letter—as "latent homosexual behavior."

After dinner, listened to Vladimir Horowitz play Tchaikovsky Piano Concerto No. 1 (Arturo Toscanini conducting), first movement, 1941, Carnegie Hall.

My new (old) Hermes 3000 typewriter is the color of my father's (1955?) Chevy, or at least the *keys* of the typewriter are that color.

Title for a novel: *My Hyperarousal.*

Michael Jackson died.

Dreamt that Debbie Reynolds told me that she couldn't really sing, despite her *Singin' in the Rain* fame.

Today would have been Jackie Onassis's eightieth birthday.

Ted Kennedy died.

Spent the day revising *Fassbinder and Plath*.

Pound, at the end of his life, was electively mute.

Touched a stinging nettle plant yesterday. I thought it was peppermint.

We drank various leftover bits of wine—a row of refusenik bottles in the refrigerator.

My mother understood that my spelling, when I was a kid, was loco.

In the audience of Philip Seymour Hoffman's *Othello*, seen up close: Liev Schreiber, Meryl Streep, Ralph Fiennes, Joanne Woodward.

Ralph Fiennes seemed to be wearing garden clogs.

Onassis met her; she didn't know who Onassis was.

Which means that this not entirely pink tablecloth's pink matters.

Dream: seeing an opera DVD or else an Elliott Gould-esque early '70s art film with some friends who didn't want to see it.

We walked by a club afterward. A pimp, barker, or huck-
ster outside said, "Any questions?" When I said, "What
kind of place is this?" he replied, "Naked girls."

We drove near a town (Ericeira?) where I'm sure my fa-
vorite Big Muscle Bears guy lives.

I imagined writing him an email, telling him I loved his
voice and his body, and I hoped that if he ever visited
New York, he'd contact me.

Why does a gay countertenor in the city of Alcobaça
appeal to me?

The lost yet heightened life—the small career—the lim-
ited circuit of bars, cafés, performance venues—the dis-
appointed hopes and unrealistic aspirations (and my
eroticism a puzzle, a lacuna, an ellipsis, a deferral . . . de
ferred until *it is too late*)?

Earlier, in Marvão, a middle-aged, drably dressed woman,
who seemed crazy or mentally disabled, or just slow (she
was moving her jaw mechanically, as if adjusting her den-
tures, or suffering from tardive dyskinesia), walked onto
the wall we were sitting on. Then, to retain privacy, or
to grant her a privacy she seemed to refuse herself, we
stepped off the wall.

Driving on country roads, I fell in love with goats—
because of the sound of their bells.

Dream: lost my black denim jacket in Mia Farrow's fancy
apartment.

She had a painting of Liza in her bedroom; a grand piano,
inches from her bed; a Deborah Kass appropriation of a
Julian Schnabel.

Two days ago I weighed 127. Last night, I weighed 126.
This morning, I weigh 124.5.

After dinner, listened to Ethel Merman sing three songs
from *Gypsy*. Then I played the fourth movement of Cho-
pin's third sonata.

Begin taking the transcription of my journals seriously as
a writing project.

Dream: Harpo was handsome but had a Hitler mustache.

Splattered balsamic vinaigrette on my pink shirt after
birdlike nibbling at a tuna salad (trying to avoid the red
onions filling it like a minefield).

Stood up on the desk, so that the air conditioner could blow-dry my shirt, wet from applying a wet paper towel.

David Foster Wallace committed suicide.

Started Doxycycline for the bite or rash on my right biceps.

Weighed 121.5 this morning, before breakfast.

I think I saw my double, Tom, on the train this morning. He spoke beautiful German.

When Gigli sings the word *l'ultima*, everything stops.

Dream: my mother offended Louise Glück.

Nathan Gluck died: tiny paid note in the *Times*.

Write an essay called "Paper Cuts."

Find a way to make diaries function as poems.

This morning I weighed 120 or 120.5 pounds. Last night I weighed 124.5.

In the shower, cute Bard undergrad offered to lend me his soap.

A guy in the locker room complimented the color of my underpants.

I asked, at one point, whether she was "overflowing with skepticism."

Being "open," as it were, to exploring the caretaker's (metaphorical?) sexual invasions of the infant body (maybe especially the butt?) lubricates the revision (and forgiveness) of this book.

Dreamt of some sexual entanglement (co-nudity) with ———, whose pillory-prone flesh haunts me—a limit-case of exposed, incestuous, hairy body-mass.

And saw sexy father Chris whose absolute unwavering straightness (combined with physical self-confidence) is ravishing and decimating.

Ate the last piece of orange cake, sprinkled with powdered sugar, garnished with apricots, cherries, black and red raspberries.

Mother, wiping the infant's ass—never certain whether she has done a good job, never sure when the task is finished.

Finished watching Isabelle Huppert in *Story of Women*. Started reading Guy Davenport's *The Hunter Gracchus*.

Davenport thinks the automobile is the enemy of true civilization.

No dinner tonight until I'm done with chapter nine.

Turns out my mother's favorite film in the world is Isabelle Huppert's *Story of Women*, about the abortionist who sexually rejects her handsome husband.

Let my next book be a longhand endeavor. Perhaps a novel? Certainly a book about texture, shininess— whether a mock-philosophical essay, or a set of focused yet wandering meditations.

Outside the restroom at the back of the train, the conductor appeared to be rubbing his crotch suggestively.

I ate two leaves of parsley, and two leaves of arugula.

I hope I haven't inadvertently destroyed my complexion.

Book idea: *Vanilla*.

"Two different obituaries / mention *The Misfits*: I think we're / on the trail of something wild" is a poem in eight-syllable lines, a tercet.

I don't understand Benjamin's "Critique of Violence."

My mother reports my stepfather sneaking out of the house to mail his absentee ballot for Obama.

Dream: I applied for a job (posthumous) working on publicity for Anna Moffo in Pennsylvania.

Perhaps find every reference to death in a year of my journals?

My pants button popped off today at school (my Acne jeans).

I read John Bowlby's *Attachment* in the hematologist's waiting room.

The hematologist wants an MRI of my liver (abdomen).

Worried excessively about dropping my hematologist, switching to another in the same suite.

Dream: Joe Brainard takes part in a scholarly panel about his work. I'm on the panel; so is Helen Vendler. My parents, in the audience, are holding a paper bag containing my possessions.

———————

Do I want to write *Walter Benjamin's Body* this summer?

Adorno's rejection of Benjamin's Baudelaire was cruel.

I read two Inspector Barlach mysteries by Friedrich Dürrenmatt. I'm starting to learn the first movement of Chopin's third sonata. Dinner tonight was pork and asparagus in the style of pepper steak.

At Lenna's baby shower I ate two cocktail wieners, wrapped in puff pastry.

Dreamt last night of Elizabeth Hardwick—a sexual advance? Mine? Hers?

In the car today, listened to Arthur Rubinstein playing Chopin waltzes; the Yale String Quartet (with Aldo Parisot) playing a late Beethoven quartet; and the first part of *Louise* with Ninon Vallin and Georges Thill. While working out at the gym, I listened to Bali gamelan

music and some Francis Poulenc piano ditties (*Thème varié?*).

A not entirely deep voice may mean he's a virgin or a premature ejaculator, or else he needs his girlfriend to be gentle.

A glass (and a half) of white wine with G. on Bedford Street. I wore my skimpiest pair of white underwear.

Shiny: Autobiography of a Sensation.

When Dr. Bronner was a kid in Nazi Germany, someone poured pee on his head, because he was a Jew. Incidentally, he was a maniac.

Reading *Don Quixote*. Dulcinea is all the nonsense we assert as the motivation for our ongoing motion.

(2005–2009)

II

NO MORE TASKS

The writer's obligation in the age of X is to pay atten-
tion. Dreamt last night of a senile woman who'd taken
up piano-playing; dementia had etherealized her fea-
tures. Like a seasoned, reputable coach, I stood behind
her while she fumbled through Schubert. The writer's
obligation in the age of X is to remember the history of
song, and to remember the reasons that troubled people
have looked toward song to relieve pain and to organize,
with other sufferers, in resistance.

◆

With curiosity and reverence, I pulled down, from the
shelf, the legendary *No More Masks!: An Anthology of Poems
by Women*, the original paperback edition, 1973, edited
by Florence Howe and Ellen Bass. The writer's obliga-
tion in the age of X is to revisit books to which we have
ceased paying sufficient attention, books we have failed
adequately to love.

✦

On a transcontinental flight I read Samuel Beckett's *The Unnamable*. I wanted to live in the crevice where words broke down, and where matter arose to compensate for the loss. Some words I found in *The Unnamable*: "grapnels," "apodosis," "sparsim," "congener," "paraphimotically globose," "circumvolutionisation," "inspissates," "naja," "halm," "thebaïd." These words—obstructions in the throat—seemed specimens of rigorous, refined accounting, of a system so late-stage, so desolate, it could satisfy description's mandate only by lodging in words virtually never used. And, while 39,000 miles in the air, I imagined an island where the only currency, for the stricken inhabitants, gumming their porridge, was the obsolete word, the rare word, the word stigmatized, in the dictionary, as "literary." I was imagining an island— call it the planet Earth—after most of it was rendered uninhabitable, where there were no words or only the most elementary words or only the most obscure words, only those words so specific, so *paraphimotically globose*, that they could function in this new, eviscerated terrain. Imagine, then, an ecology of language, where only "cang" and "ataxy" can make the rivers flow, where only "serotines" and "naja" can serve as verbal cenotaphs for the missing bodies, whether made of words or of matter, that failed to arrive at this final, spectral island. If we don't

live on that island now, we may, one day, and we might not be "we" any longer; we might be sparse tuft or diatomaceous phlegm.

+

Long ago I knew a little boy who was afraid of diatomaceous earth—a bug killer made from "the fossilized remains of marine plankton," I learn from a website that sells this product, or defines it, or rails against it. I knew a little boy who was afraid that the presence of diatomaceous earth in the family's garage would destroy his lungs. He feared that diatomaceous earth would insinuate its chalky presence into the house itself. The patriarch of that house had a name almost identical to the nineteenth-century German peasant who discovered diatomaceous earth. The name of that peasant, Peter Kasten, closely resembles my father's name; the only object missing is the suffix "-baum." The only object missing is the tree—not the actual tree, but the name for the tree, which is itself the sign of a so-called race, tribe, or population for whom poisons would eventually matter. There are no tribes for whom poisons do not always matter. Poisons mattered to the boy—not me, but my brother—who lived in the house adjacent to the garage containing diatomaceous earth. I imagine that my brother feared the diatomaceous earth not simply because it was possibly

toxic to human lungs but because its first discoverer bore a name similar to our father's. And so, as Michel Leiris and other word-unveilers have noted, we travel into our stories—our bodies, our destinies—through the words that accidentally or deliberately serve as the vessels holding the material facts, the powders, the liquids. I will say "unguent" here because I seize any opportunity to say "unguent," not because I want perfume or healing or exoticism but because I want vowel mesh, I want a superabundance of the letter "n," hugging its "g," and I want the repeated, nasally traversed "u," which is an upside-down "n." *Unguent.* And thus we dive into that aforementioned crevice where words crossbreed: my brother feared death at the hands of a bug killer discovered by a German man whose name uncannily resembled the name of our German father.

✦

The writer's obligation in the age of X is to play with words and to keep playing with them—not to deracinate or deplete them, but to use them as vehicles for discovering history, recovering wounds, reciting damage, and awakening conscience. I used the word *awakening* because my eye had fallen on the phrase "to wake the turnkey" from *The Unnamable.* Who is the turnkey? The warden who holds captive the narrator, if the narrator is

a single self and not a chorus. "To wake the turnkey" is
a phrase I instinctively rearranged to create the phrase
"to wank the turkey." Why did I want to wank a turkey?
Is *wank* a transitive verb? According to the OED, the
word's origin is unknown, and it is solely an intransi-
tive verb, which means it has no object. I cannot wank
a turkey. You cannot wank a turkey. We cannot wank a
turkey. They cannot wank a turkey. The turkey could
wank, if the turkey had hands. I have no desire to in-
vestigate this subject any further. Before I drop it, how-
ever, let me suggest that Beckett's narrator, the solipsist
who paradoxically contains multiple voices, is, like most
of his narrators, intrinsically a masturbator, as well as
an autophage, a voice that consumes itself. The writer's
obligation in the age of X is to investigate the words we
use; investigation requires ingestion. We must play with
our food; to play with the verbal materials that construct
our world, we must play with ourselves. Producing lan-
guage, we wank, we eat, we regurgitate, we research, we
demonstrate, we expel; with what has been expelled
we repaper our bodily walls, and this wallpaper is in-
tricate, befouled, and potentially *asemic*—nonsignifying
scratches without a linguistic system backing them up,
scratches we nominate as words by agreeing together
that this scratch means wank, that scratch means cang,
this scratch means diatomaceous, that scratch means
masks.

✦

Susan Sontag once praised a maxim by the painter Manet, who said that in art "you must constantly remain the master and do as you please. No tasks! No, no tasks!" I often quote Sontag quoting Manet. Writing is a terrible task. It is also, sometimes, a pleasure, but it is more often a task. The arduousness of the task, and the succulence of the pleasure, are coiled together. For Sontag, writing must have often been a task, and she was often fleeing the task, even in her own writing. It's possible to read any of her sentences as a round-trip flight between pleasure and task. The flight grows marmoreal—hardened into its pose—and that state of stillness-in-motion (a modernist ideal) is her finished sentence. "Mastery," as Sontag, quoting Manet, constructs it, is a matter of fleeing task; we flee the task to become the master. Mastery, a dubious concept, needn't be our lodestar; we can flee task not in search of mastery but in search of circumvolutionisation. More on circumvolutionisation in a minute.

✦

"No more masks! No more mythologies!" So goes the passionate cry uttered in Muriel Rukeyser's "The Poem as Mask." *No more tasks*, I say, crossbreeding Rukeyser's phrase with Sontag's (or Manet's) "No tasks!" *Mask* and

task are two nouns—two behaviors—I love. From Os-
car Wilde come masks; from the Marquis de Sade, and
from Yahweh, come tasks. After Eden, masks and tasks.
In Eden, we had neither. Literature—the respite of the
fallen—is the process of making do with mask and task,
diverting ourselves with tasks that mask our disenfran-
chisement. We are disenfranchised, regardless of our
station, because we belong to an earth that will con-
tinue to bear our presence only if we remain adequate
custodians of this material envelope, fragile, in which we
dwell, an envelope consisting of just a small interval of
habitable temperatures. To unmask the systems that will
destroy our possibility of inhabiting the earth is the task
of a language that operates through masks and the avoid-
ance of tasks. Past the obvious tasks we fly, in search of
tasks more stringent, more personal, more flawed, more
seamed, more circumvolutionary. Circumvolution must
be voluntary; no master can impose it. Beckett's word,
circumvolutionisation, is not in my two-volume abridged
OED. Perhaps the word does not really exist. Perhaps it
exists only in Beckett's mouth, or the mouth-mask that
we call a novel. To flee the words we have been allotted by
an immoral system that wishes to *drain the swamp* (as the
current political administration describes its wish to de-
stroy governance), and to seek circumvolutionisation, if
circumvolutionisation turns you on, are the simple med-
icines I stand here to offer you. *Circum-* means "around."

Volvere means "to roll." In my dream last night, the senile woman playing Schubert on the piano had sat, a few dream-moments earlier, gossiping with fellow sufferers in a room usually given over to psychoanalysis; my crime, in the dream, was either that I had crashed a borrowed car, or that my existence was filthy and inadmissible. In the dream, gobbets of mud were stuck to the bottom of my Blundstone boots. Homoeroticism lay encrypted within those muddy clods. My soiled homo-boots sat on the porch of the senile woman who'd been practicing her flawed Schubert. Dirt's movement into and out of a house has always been the topic I circle around, and I beg you to take my circumvolutionisations as seriously as possible, and to eat them, as you would eat an allegory, biting hard into its brittle exterior, like an unfriendly candied almond, *Mandelbrot, Mandelbaum.*

(2018)

FIGURE IT OUT

I.

Desecrate. Commit an iconoclastic act. Gently ruin an object, a place, a possession. Take a fingernail clipper and scratch the wall of a public building. The post office would be a good choice. The scratch you make will be very tiny and therefore not entirely illegal; the scratch won't interfere with the mail delivery and so you don't need to feel guilty afterward.

2.

Divide your living space (or your work space) into areas consecrated to different activities. The internet corner. The meditation corner. The sex corner. The reading corner. The chopping celery corner. The remorse corner. These corners may all end up being the same corner, but invent ways of differentiating the functions. (I learned this trick from Anaïs Nin's diary.)

3.

Find in every orgasm an encyclopedic richness. Take the lessons of orgasm and apply them to daily life, as if orgasm could be extended. Behave like an orgasm, without alienating people, breaking laws, or losing credibility. Reimagine *doing the laundry* as *having an orgasm*, and reinterpret *orgasm* as not a tiny experience, temporally limited, occurring in a single human body, but as an experience that somehow touches on all of human history.

4.

When I write, I start to feel grandiosely world-historical, like a German poet or philosopher who wants to rewrite the story of human endeavor. Stop trying to be Marx or Freud. Or else finally read that biography of Wilhelm Reich—king of the orgasm—that has been sitting on your bedside table ever since al-Qaeda flew two planes into the World Trade Center.

5.

After someone insults you, or ignores you, or makes you feel like dirt, buy a box of charcoal and a cheap pad of newsprint, and go to town with it. Make random marks on the newsprint, each mark signifying your revenge against the person who made you feel like dirt. Perhaps blindfold yourself before going to town.

6.

Use a stopwatch to time various ordinary activities (like making the bed or reading a story or boiling water for tea) in order to develop a curious attitude toward these usually unscrutinized acts. Make the bed *very slowly*. Notice the nubbly sensation of the maybe not pristinely clean sheets against your fingertips.

7.

Make a new decision about color. Banish green from your affections. Commit yourself to blue. To orange. Take up puce as a calling. Stop playing favorites. If you've always considered red your ideal color, stop wearing red. Move on to yellow. If you're bored with yellow, find micro-shades of yellow *within* yellow. Realize that yellow is itself a complicated region, containing Naples yellow, lemon yellow, gamboge, cobalt yellow lake. Find a new favorite among the minor, oddball yellows.

8.

Pattern: develop a philosophy of polka dots, stripes, paisley, plaid, or randomly intersecting lines or curves. By "philosophy," I mean a complicated attitude toward the pattern, and one that is yours alone. Everyone in the city might be wearing polka dots, but let your attitude toward polka dots be uniquely yours. Individualize your attitude toward polka dots. Proclaim that attitude and stick to

it. Figure out a place in which to proclaim it. Try to re-
member when you first fell in love with polka dots. If
necessary, find a way to describe the pattern, something
other than "polka dots." Instead of polka dots, call them
identity spots.

9.

Buy a one-dollar cactus, and start anthropomorphizing
it. Call it Sabrina. *Hello, Sabrina. Would you like a little water
today?*

10.

Find a friend whose creative life is thriving. Ask this
friend some detailed questions about how to thrive.
Yesterday a poet told me that he writes at night for six
hours without interruption (except for caffeine breaks).
The next day he harvests the good parts from the mad
kaleidoscope he'd assembled the night before. I asked
him, "How do you retain the weather system of the
kaleidoscope? How do you prevent yourself from ru-
ining the healthy ecosystem you'd concocted the night
before?"

11.

Exaggerate the pain that a certain incident gave you—for
example, the time that you almost bumped into an old
man on the sidewalk, and he growled and cursed at you,

waving his hands as if warding off a devil. If that old man on the sidewalk upset you, and his excoriations felt like rape, exaggerate the pain. Beef up the plight quotient of the incident. Develop a series of rituals to ameliorate its effects.

12.

Behave like Gena Rowlands in *Woman Under the Influ-ence*, but only when by yourself. Have a *behave like Gena Rowlands* hour, when you allow yourself to go theatrically crazy. Do it in a room, like the kitchen, that has plenty of wet and messy substances (ketchup, milk, sherry, honey, yogurt, miso) available for your use.

13.

Categorize your crushes. Figure out what they have in common, over the years. Tally how many of these crushes came to fruition. Figure out what *fruition* means for you. (Sexual consummation? Reciprocated affection? Monetary gift?) Figure out whether you have "used up" that category of crush, and might need to discover another category.

14.

Modify your body this afternoon. Perform this mod-ification more slowly than usual, and allow yourself to make metaphors of what the process means to you.

15.

If you need to shut a door, shut a door. Right now.
Lock it.

16.

Always travel with a small stash of nutritious and filling
foods. Figure out whether you want to share the stash or
keep it to yourself. Figure out whether it will upset you if
other people reach with their bare hands into your stash.
If you find it difficult to eat food in front of other people,
find private moments for compensatory nibbling, or else
tell the people you're forced to be with, "Excuse me, I
need to make a phone call," and go into the corridor and
stuff your face.

17.

Don't interrupt other people when they're in the middle
of talking, unless they are unrepentant loudmouths, dy-
ing for correction.

18.

If you like some aspect of a person, say so enthusiasti-
cally, and find an original way to praise that aspect of the
person's comportment, appearance, or performance. Be
sure to smile while you issue the praise, and issue it with
full sincerity, even if your feeling may be divided.

19.

If someone once asked you for an important favor, and you never did the favor, even if you said you did or let the person believe you did, then realize that you might have been *doing the correct thing* (for yourself, for the other person, for the balance of the universe) by not executing the favor. Realize that there might have been a divine, undetectable correctness in your failure.

20.

Choose a short piece of music. Lie down on the floor, not the bed; a certain discomfort is essential to this experiment. Close your eyes, and listen; consider this music the antidote to any assault committed against you. Pretend that the main melodic line represents you, and that the accompaniment represents all the forces that are standing behind you. You might not be aware that a chorus of powers supports your existence, but in truth you couldn't be alive without this choir of invisible angels devoted to sustaining your life. Consider each blood vessel in your body to be an unacknowledged angel, consecrated to your welfare. When the music changes key, consider the modulation to represent a movement into your enemy's point of view; be glad when we leave that key behind and return to the original. Later, when you have attempted to practice my suggestions, and you begin to see the results,

you will notice that "enemy" is no longer a load-bearing column in your personality's solid cathedral.

21.

Stop being a perfectionist. Or limit your perfectionism to brief interludes, in which you're allowed to go "whole hog" on the perfectionist path; but then, afterward, institute a scheme that permits an instantaneous crossover to nonperfectionism, license, ease. I advocate extreme cleanliness but I also advocate wallowing in your own filth.

22.

Start remembering your dreams by telling them to someone, or writing them down. Take your dreams seriously. (Last night I dreamt that I was forced to be prime minister of a tiny island-nation torn by centuries of civil war.) Try to keep the aura of the dream around yourself for as long as possible during the morning, even if the dream's atmosphere interferes with your functioning.

23.

Choose to identify with a person in the news. Bo Guagua, son of a Chinese Communist Party leader. Call yourself "Bo Guagua." See if it helps. It might give you a few unearned liberties. Make a list of those liberties, and title the list "Bo Guagua."

24.

Cultivate your affinities, not your aversions. If you don't like a book, try to like it. (I didn't entire delight in Herman Melville's *Pierre*, though I wanted to love it.) Find one tiny aspect of the book to fall in love with, even if this aspect fills you with discontent and unrest. (*Pierre* is about brother-sister incest, and I tend to like novels about brother-sister incest.) Find a way to cozy up to the unrest, to find in that discomfort a mode of home. I am not recommending that you take up brother-sister incest as your next "cause" to stand behind. But if brother-sister incest is necessary (as an imaginative category) to sustain your interest in a book you'd otherwise dislike, then I recommend encouraging your brother-sister incest fantasies as a way of stimulating yourself to enjoy *Pierre*.

25.

If you are not happy with your own body, or feel underconfident about one aspect of it, find someone to perform a compensatory act of worship. It will be easier than you think to find an acolyte. Make sure that this person worships your body in detail and verbalizes the ceremony while it is taking place. Perhaps record the session, so you can listen to it for future consolation.

26.

Make a list of all the items you've recently googled. Turn each item in the list into a question. If you googled "Bobby Darin," for example, you might transform that impulse into the following question: "If I were to buy a houseplant and call it 'Bobby Darin,' what kind of plant would it be, and how long would it live?" Perhaps take this exercise one step further, and *buy* a houseplant, name it Bobby Darin, and see how long it lives.

27.

Sit by yourself in a public place for one hour, with a pad or notebook, whether for the purposes of drawing, writing, doodling, making random inscriptions, even just writing your name again and again, or writing the names of every item of food in your refrigerator (from memory). Even if nothing that you write or draw proves interesting to you later, you will have attracted the attention of fellow-dwellers of this space, and you will have befriended your hand.

28.

Dedicate each sexual act to a specific scene from your past, particularly a scene that represented a site of non-fulfillment, chagrin, or pain. Give that scene a title.

29.

Verbalize every impulse. Or else take the silent route; let your impulses live without the punishing, restrictive mantle of words.

30.

If you regret not attending someone's funeral, tell yourself now that it is too late, and no harm was done by not paying your respects at the grave. If you still believe that harm was done, realize that "harm" is usually subjective, and therefore liable to interpretation, and that it is possible that the only harm done (by your nonattendance) was to yourself, and that you can erase this harm—right now!—by telling yourself that you were *justified* not attending the funeral. If you want your heart to be broken, though, remember that the first time you met the now dead man, he said, "Come sit on my lap," and you sat on his lap. And ask yourself if you are a kindhearted person to have skipped the funeral of a sage on whose intelligent lap you'd once sat. But then decide that the category "a kindhearted person" is a construct meant to promote unhappiness, and that no person is uniformly kind from dawn until dusk. Kindness erupts in specific, tiny moments, and then it vanishes.

31.

Buy a stuffed animal. I don't care how old you are. Keep
the stuffed animal in a private place. Name the creature.
Jonathan Edwards. Dorothy Day. When you need advice,
ask the toy for advice. Whisper a question in its ear. Your
question must be asked with absolute sincerity, a degree
of guilelessness that can be quantified. After you've asked
the question, put the animal's mouth to your ear, and lis-
ten to the answer. The fetish will speak directly and sim-
ply. Listen carefully to its advice, and obey it to the letter
of the law. After the fake-furred oracle has spoken, say
thank you to it. "Thank you, Dorothy Day," you may say
to your stuffed octopus, "for your excellent advice."

32.

Get rid of guilt. Find a place in the out-of-doors to bury
your remorse. Take a shovel, if necessary, and dig a small
hole for your guilt, even if the hole is in the middle of a
public park. Ceremonially deposit your burden in that
hole, and then throw dirt on top of it.

33.

Notice your own tendency to shift quickly from divine
source of vivacity to foul-smelling dirt clod. Wonder if
that speed of transit from vivacity to dirt clod is itself a
normal human tendency, or whether it is a peculiar and
changeable feature of your own temperament.

34.

Watch a spider gradually approach a fly, caught in a web. Watch the fly squirm. Watch the spider's remorseless approach. Watch the spider devour its victim. And then reconsider an act—or an omitted act—for which you feel guilt. Ask yourself: am I as maleficent as the spider? Is the spider immoral? Or is the spider fulfilling its destiny as spider? To fulfill your destiny as human being, what fly must you consume? What fly must you make squirm? Or can you renounce your likeness to spider, and decide never to consume, never to make the other squirm? This renunciation may not be possible. And so resign yourself to sometimes making the flies squirm. List your flies. Some of the flies may not be human beings. Some of the flies may be abstractions.

35.

Does a specific part of your body hurt? Devise questions to pose to that soreness, but don't expect direct answers. Perhaps you need a heating pad, not a new set of metaphors.

36.

Do something until you are very tired. Keep doing it, just a little past the point of fatigue. Something repetitious. Keep washing the juice glasses. Notice the sensation of fatigue in your fingers and wrists. Think of that fatigue as a tunnel toward something else. You don't yet have a

name for that something else, but that nameless *other place* is where your best (post-fatigue) energies are directed, and where you will achieve the only fruition possible— perhaps a meager fruition, but nonetheless a reward. Define the fruition. Can a fruition that stems from fatigue be glorious and pleasure-giving? That's another subject: the secret dividends of hypnagogic states.

37.

Arrest yourself in the limbo between wakefulness and sleep. Just as you are on the verge of falling asleep, pull yourself from the abyss, and linger there. Observe your physical sensations as you hover on the edge of sleep, not quite falling in. Do you see specific colors or geometric shapes? Do visual patterns emerge? Filmy textures, like the skin surrounding chicken livers or beef hearts? Do phrases suddenly appear in your flickering consciousness? *Avanti Dio. Tidal wreckage. Variorum sandwich. Earl Grey bottom.* Do these messages seem allegorical? What, for example, does "tidal wreckage" symbolize? Are there specific images—in the hypnagogic bath of sensation—attached to the phrase "tidal wreckage"? Linger as long as possible in this limbo zone between sleep and wakefulness.

38.

If a sound from your environment (car horns, lawn-mower, dog's bark, street repair) bothers you, prevents

you from sleeping, or leads to a train of negative thoughts, decide to analyze the sound instead of simply objecting to it and considering it your enemy. Notice whether the sound increases or decreases, gains intensity or loses it. See if the sound is actually composed of several different sounds. Most sounds are composites of various pitches and timbres. Break the sound back down into its constituent parts, and consider that maybe the individual parts are not bothersome; only the confluence causes distress. Ask yourself what the sound reminds you of. When did you first hear a sound of that kind? Did you always hate street repair? Did you always hate the sound of dogs barking? Imagine the dog's bark from the dog's point of view, or from a vet's. Imagine that someone else might hear the dog's bark as a sign of love, a cry for help, a consoling Morse-code pattern, a hip-hip-hurray. Allow yourself to feel grief-struck that you are now in the process of extricating yourself from your own point of view. The dog's bark is forcing you to become an alien to your own body. And so you have a right to hate the dog and wish it dead. But: you do *not* have the right to kill the dog, or to cause the dog any suffering. You must endure the dog's bark, which is God's special message to your dirty little self: you, too, are nothing but a dog, nothing but a slavering creature liable to urinate on fire hydrants and to defecate in the sandboxes of neighborhood children.

39.

If you require silence for peace of mind, take every pos-
sible step to produce a quiet environment. Buy earplugs
or a noise-canceling device. Don't shame yourself for
wanting silence; don't question your lifelong habit of
demonizing random noises. Last night I heard a man or
woman shrieking and the sound of cars slamming into
each other. I looked out the window and saw a man or
woman lying flat in the middle of the street, with stopped
cars splayed around the body. I realized that someone
had been hit, and that a sound I'd considered merely ir-
ritating was for someone else the source of direct phys-
ical trauma. And so my own wish for sleep and silence
became a momentary devil—a pampered desire I could
demonize. I could shame myself for wanting quiet.

40.

Remember a sexual experience from your past. Try to
remember what your attitude toward the experience was
while it was taking place. Were you excited? Were you ner-
vous, bored, ambivalent? Did you feel rushed? Unpre-
pared? Coerced? Were you too aggressive? Too passive?
Now ask yourself if you still have the same attitude to-
ward that sexual experience. If, for example, you remem-
ber feeling ambivalent, do you now feel nostalgic about
the experience, and remember it as a cameo from the
golden age of your erotic awakening?

41.

Watch a huge bee dive-bomb a flower. Notice the bee's directness but also its precise, mannered choreography— the fussiness of its approach to the flower. Notice the bee's ADD, its tendency to lose interest in a flower it had just a moment ago adored. Do you consider the insect a benighted creature, subject to compelled behaviors? Or do you consider this bee a paragon of a body at one with its destiny? Does fear of bees prevent you from trying this thought experiment? Take a moment to consider the bee's predations from the flower's point of view. Does the flower welcome or tolerate the bee's visit? Is the flower destined to permit random invasions? Is the flower a *lesser* creature—merely a vessel, a landing site, a fecund ornament? Was your recent conduct floral or beelike? If you have behaved like a bee, try, for a day (or even just for an hour), to assume the flower's mode.

42.

Do you consider every housefly you've greeted in your life to be essentially the same fly, or variations on the same fly, or do you grant each fly its own identity? If a fly happens to be buzzing in your vicinity as you read this paragraph, get a flyswatter or a rolled-up newspaper and kill the fly. Now contemplate the dead insect. Does it represent a unique loss or a generic absence? Has the grand total of *fly consciousness* in the universe

diminished or remained the same? If there happens to be more than one fly buzzing around you as you read this paragraph, try this time *not* to kill the flies, and simply to notice (or even to enjoy) their aerial voyage. Ask yourself whether each fly has an identical drop of fly consciousness, or whether the flies lack consciousness and are analogous to our toes and fingers. Your big left toe does not have a consciousness separate from your big right toe. Or does it? Does each of your two big toes (assuming you have two feet, which is not a universal condition) possess a differentiated will, a separate mission, a distinct claim on a beneficent God's attention? Would you wish to be cruel to your toes, and to say, in their presence, *I prefer the left toe*, or *I prefer the right*? Is it not of paramount importance to act equitably toward both toes, to let each toe pursue its own course and enjoy its own sensations, and to be entitled to call its sensations *mine*?

43.

I'm waiting in line at the sandwich shop. I'm in a good mood. The government is shut down today but the post office is still open. It's LA weather in October in New York: unseasonably sunny and warm. A woman holding a baby boy has ordered a sandwich and is now departing. In a burst of kindness I get out of line to help the woman by opening the door. She says, "Thank you." The baby

smiles at me. Meanwhile, the man who had been waiting in line behind me—he looks like a fashion model—has silently glided over and stolen my place. I gently try to reinsert myself into line, in the same position I'd been standing earlier, before I'd absented myself generously to help the mother and child. The fashion model seems unaware of my existence. I am filled with anger at this arriviste, and torn between rival options. Should I say, "Excuse me, this was *my* place in line"? Should I cede my former station to him? I refuse to capitulate. He gradually gets the message and allows me to reclaim the position I'd earlier staked out. But I don't know what to do with my excess rage at this fashion model who took over my place in line without looking directly at me to acknowledge my presence. He simply stepped right over where my body had formerly been. Later I might cut this paragraph, because it doesn't give advice; it merely complains. To this complaint, there are no solutions. Nor is there a solution to the rage I feel when I see another man in line allow his pet dog to lift its paws onto the counter—where the sandwiches will be placed—and scrape the countertop and nearly lick it. I happen to be friends with that man, the man with the dog who is invading the countertop with dog scratches and dog tongue. I could say to this man, my friend, "Excuse me, but you should prevent your dog from licking and scratching the counter where human beings place

their sandwiches." You see that my emotions, if I allow them free rein, lead toward anarchy, disillusionment, rudeness, alienation, fines, fistfights, name-calling, and, possibly, prison.

(2017)

ODD SECRETS OF THE LINE

<div style="text-align:center">I.</div>

"Strive for passive-aggressive ekphrasis," I cautioned myself, wishing to avoid what responsible critics call *a coherent argument*. (As Rosalind Krauss writes in *The Optical Unconscious*, "Of course, it's easy enough to laugh at Ruskin The most analytic mind in Europe did not even know how to frame a coherent argument.")

I planned to turn my back on argument; but then I changed my mind. Taking an embarrassingly old-fashioned position, I decided to focus on the line. Huge differences separate the artist's line and the poet's, but I decided to lump them together and to speak as the line's prophet, its infatuated scribe. The line, I vowed to assert, represents the unerring rightness of the hand's will. (How Germanic!) I'd lump together the line and the gesture, the curved and the straight, the thick and the thin, the obelisk and the curlicue, the outline and the internal scratch, the smear and the indentation, the fold and the crease, the wiggling perimeter and the frottage-induced rivulet. I'd lump together every line I'd ever seen

and loved, whether Ezra Pound's or Louise Bourgeois's, Jean-Michel Basquiat's or Mina Loy's, Michelangelo's or Chloe Piene's, Adrian Piper's or Charles Olson's, Anne Sexton's or Jean Dubuffet's. I decided to feed my appetite for hasty summation on the line's ample (and not yet funeral) meats, with the aim of inspiring writers and artists to make their lines more strange, more self-confident, more wandering, more meager, more resolute in refusal and adhesion. I decided to lump together the poetic line and the drawn or painted or photographed line, not because I insisted that every difference vanish, but because I wanted to approach more closely what I love—the line, both as a measure of duration (iambic pentameter) and as a mark of charcoal traveling a specific itinerary, intended or accidental, across an acid-eaten page.

The line, beyond my power to summarize, matches Gertrude Stein's ideal cow, her license to explore the continuous present of composition, whether with a gerund, a past participle, or a grazing finger. The line, never a liar, never "bad" or "good," rises before me as a tactile utopia, an event that you, as a human being, can manufacture, if only through intensive wish and a 3B pencil.

My statements, elementary, are political exhortations, part of a gradually assembling platform of art activism, whose final contours I hope will exceed the reach of the Situationists; don't let the simplicity of my statements

deceive you, or prevent you from estimating, at full value, my communitarian enthroning of the line-making impulse as a heaven we can occupy today.

Ink, paint, graphite, food, sewage: these substances make lines. The line begins and ends; its end (like any trickster's or saint's) recapitulates its beginning. The line lacks a genuine middle; or maybe its middle is muddled. Paul Klee and Vasily Kandinsky divided lines into several categories. In capricious acts of faux-systematization, they created line-drunk taxonomies. Klee and Kandinsky made those generalizations early in the twentieth century, a good time for making grand claims. Now, in the beginning of the twenty-first century, one hundred years after Kandinsky helped invent abstract painting, one hundred years after the Armory Show, we can't surrender to spartan hypotheses, but we face a political and historical predicament in which very simple statements may be the only sane thing we can offer.

A different, more labyrinthian version of this essay might discuss a certain Picasso painting that, like a drawing, consists of merely a few lines—lines inscribed not only for the information they convey, but also (presumably) for the sensation of pleasure, mastery, pride, or release that the making of the line afforded Picasso's hand and soul. Maria Callas, in an interview, used the word *soul* to describe a singer's process of intense listening. *Soul*, not the ideal word, mystifies. The first thing

I learned in college was to stop mystifying. Most of my papers, however, performed stealth acts of mystification. I mystified anything I could get my hands on. Mircea Eliade's notion of "sacred time" inspired my collegiate mystifications. No one talks any more about Eliade. Smart people still occasionally talk about Gaston Bachelard—timidly. They feel the need to apologize for Bachelard, because he mystified rooms, corners, nooks, attics, thresholds, closets.

André Masson's lines prefigure Jackson Pollock's—if we believe that art history moves forward rather than in circles, a retrograde rondo that Alexander Nagel sketches in his book *Medieval Modern*. Masson, a mystifier, made automatic drawings that don't look very automatic. Masson suffered a severe wound in the First World War. I don't know the nature of his wound. Perhaps it resembled other major masculine aesthetic wounds—Henry James's, Ernest Hemingway's, Guillaume Apollinaire's. Major modernist wounds, all of them. Masson's wound might have made him a mystifier.

Egon Schiele was not a mystifier. And yet observe his final (or nearly final) drawing, which depicts his wife, Edith, the night before she died, just two or three days before Egon himself perished; this ultimate drawing, like a perfume atomizer, mystifies. His lines mystify wife, mystify life, mystify the artist's role as humble servant of truth. He renders her nose

accurately—quasi-photographically—but also mystifies
it. When I copied the drawing, my hand a yearning im-
itator's, I clumsily enlarged her features. I turned her
quasi-Roman nose into a Jewish nose.

Egon Schiele's line, unlike an amateur's, forgets to
fail. His line often captures the look of perversion, but
to call his line "perverted" performs a back-alley mysti-
fication job on it.

A few years ago, an art critic accused me of avoid-
ing argument. That insult contained a grain of truth.
I pretend to avoid argument, or to bury it in a flood of
verbal ornamentation. I need to hide my argument—or
hide from myself its very existence—because random de-
tails restore my birthright optimism, while strict argu-
ment fastens me to an electric chair. I avoid argument
because I don't want to get into fights. But maybe, now,
if I talk about the *line* only in the most general terms,
with few references to literature or art, then I intend to
pick a fight over the right—anyone's—not just to a line,
but to *the* line; as if every line secretly enlists in a larger—
global? network of lines; as if the line, made with pen,
brush, or hand, occupies a larger fiefdom than a single
person dared possess.

2.

Listen to Emily Dickinson, in 1860, delineate her en-
counter with the other side:

Just lost, when I was saved!
Just felt the world go by!
Just girt me for the onset with Eternity,
When breath blew back,
And on the other side
I heard recede the disappointed tide!

Therefore, as One returned, I feel,
Odd secrets of the line to tell!

When Dickinson limned her almost-encounter, her aborted divine audience, her coitus interruptus with the void, she described the information she came back to report as "odd" and "secret." She won't actually deliver the news in the poem; she'll only do a feint—a mummery— of delivery. Full disclosure will happen elsewhere, outside the poem. Delivery will happen "next time," after she has prepared herself for numinous audition. Delivery will happen after she dies, when her poems, delayed for lack of sufficient postage, finally achieve transmission. She'll need to wait until her right, odd moment arrives—a moment that remains entirely promise. In place of tale-telling, she subsists on a triumphant diet of braggart exclamation, confessing the presence of a full knowledge she lacks the liberty to disclose.

She compares her predicament, as witness, to that of "Some Sailor, skirting foreign shores." The Sailor doesn't

wear skirts, but then why do this metaphorical mariner's navigations qualify as "skirting," a process affiliated with feline, undercover acts of sabotage and refusal? Dickinson also compares herself to "Some pale Reporter, from the awful doors / Before the Seal!" We won't get lost in ruminations, now, about the "Seal," but we will pause on the word *pale*; we will ask if this Reporter's pallor indicates racial whiteness (the line to which she refers might be the Mason-Dixon Line or the color line), the blood-drained face of terror, or familiarity with a reportorial turf legendarily known, like Siberia, as "beyond the pale."

Dickinson's declarations occur in verse lines. Critics have questioned the exact nature of Dickinson's lines, and whether their arrangement on the published page reflects her intended choreography. But let's assume, for the moment, that she intended to write in lines. At least once, she uses the word *line* to describe the incremental stations of a poem's flight down a page. In August 1862, she wrote to her aesthetic confidante T W Higginson, "I marked a line in One Verse—because I met it after I made it—and never consciously touch a paint, mixed by another person—"

I feel preternatural curiosity about what makes a person choose to tumble out her thoughts in lines, measured or unmeasured, rather than in the stately and functional, if pedestrian, equipage of prose sentences and paragraphs. We already know that the distinction between

writing in verse lines and writing in prose has philosophical legs; in a Shakespeare play, when a character speaks prose, rather than verse, we surmise differences in dignity, station, seriousness, and orderliness.

The question "Why did Dickinson write in lines?" hides a swarm of nearby questions. In a letter, when Dickinson moves from prose to poem, what changes occur in the atmosphere? Can we always alter the humidity by shifting from unlineated prose to lineated poetry? When we enter the "line," do we sink into a sonic chamber of echoes and murmurs, an intertext that, like a cathedral, whether in Canterbury or in Cleveland, occupies a metaphysical location always the same? When, as writer or reader, you enter the poetic line, do you stumble on a force field of cohabitations resembling Stéphane Mallarmé's or Edmond Jabès's postulated "Book," a sumptuous plenum transcending individual signature? Does the line's size—a vast circus tent where "the onset with Eternity" always *almost* happens but never clicks permanently into gear—exceed Dickinson's measured plot of space, an avowedly puny cubicle?

The term *online*—the internet—signals a Dickinsonian state of potentially rapturous or engulfing presentness-to-all-visitations. When she writes a poetic line, or places herself in the posture of readiness to write a poetic line, she rises, in our contemporary, electronic sense, to "online" status: available, receptive, projective.

The poetic line, a grave and timeless portal, requires a very simple password. Dickinson concocted her password—irrevocable, unhackable—from metrical and orthographical materials. By writing a line that has a family resemblance, however odd, to iambic pulse (whether trimeter, tetrameter, or pentameter), she signed on. Let us therefore not underestimate the serious stakes of stepping into the sanctuary—live, wired, hooked up—of the poetic line, literally the same line your aesthetic foremothers and forefathers used, the same line your enemy uses, the same line the dead poets still use, the same line the future's poets will use, if we can count on a future.

I'm still addicted to Mircea Eliade's sacred time. I treat the line as an ethical or phenomenological or faith-based category, like the Crucifixion, that re-manifests itself in every telling, in every rehearsal; in every botched, fallen, provincial simulation. A bad poetic line in Boise is still *the line*, the very line whose odd secrets Dickinson was entrusted to tell, though her gait was, supposedly, too spasmodic to get the message clearly out.

3.

Will my blood-sugar level permit me to pay attention, briefly, to a painting by Picasso, in my principled effort to defend the line—my birthright, and yours, too—as zone of blissful possibility?

I don't want to call the line "phallic." I don't want to

call the line "not phallic." And so I won't pay attention to exegetical traditions that preach the line's code-traversed identity, its lack of freedom to espouse whim; instead, I'll side with those who claim that a line can do anything—lift Lazarus, undo meaning—as well as those who claim that a line can do next to nothing. Even a fat line, like Picasso's in his plump-line phases, makes minimal impact on the mind, or on a mind not eager to be marked by trespassing footprints.

It embarrasses me, however, to talk about Picasso, especially after looking through the catalogue from his 2012 show at New York's Guggenheim Museum, an exhibition which focused exclusively on works that eschewed color in favor of white, black, and gray; whenever I look through this catalogue, in search of a painting or drawing that will exemplify Picasso's identity as he who puts in motion the line's noblest possibilities, the image I find usually portrays a woman or a man. These days I favor Picasso's neoclassical works, which recall Ingres by rendering, with a serenely gracile or bloated refinement, bodies and faces mostly through outline: a contour drawing. And when I discover, embarrassed, that the most beautifully Ingres-esque Picasso works depict men and women, the women sometimes nude, the men less frequently nude, I grow afraid that this circumstantial coupling of Ingres-esque contour line with "man" or "woman" tendentiously argues for a symbolic equivalence between line (as formal

tool) and codified gender, as if, because line in Picasso's hands does such a good job of creating the sign of "man" or "woman," then line exists merely to elucidate gender, rather than to serve as wily double agent.

A new realization tempers my unhappy conclusion that gender and line conspire. In Picasso's works, there exist cease-fire instants when an indescribable bloom enriches, muddies, and tranquilizes the painting's underlying texture, the abstract substrate beneath the human figure. Picasso's line, whether drawn, painted, or incised, rests on an ambiguous ground, resistant to code.

The ground halfway un-genders the line; the ground—existing in a molten, uncreated, latent state, not quite shaped by describable intention—evokes the *informe*, the unformed, the not yet, the reluctant. The line performs its own baroque monologue, as if deaf to the underlying ground; the substrate, sometimes cooperative, sometimes oblivious, emits a cloud of John Cage–scored static through which we hear the incongruous line of a Sephardic monodist.

Picasso's line is perfect. (See Elizabeth Bishop's "The End of March": "A light to read by perfect! But—impossible.") Picasso's line—perfect, impossible—ignores its ground. Line not only surpasses or subsumes the ground but also fails to match its earthen inexactitude.

Many viewers—myself among them—might prefer the ground, not the lineated figure; for years, I, too,

preferred the inchoate underlayer, for I found its murmurings more contrapuntal, more receptive to distraction's profundity, than the didactic, prowess-proud, Beaux-Arts-trained line. But now the line—and the realization that a complicated human being can decompose to the status of mere line—offers greater comfort.

Mere line—contour line, without modeling—gives pleasure, though in the case of *Man with Pipe*, the face and the pipe-holding hand receive shadowy gray modeling, as if migration from pure contour into volume's compromised empire caused heightened melancholy.

The beauty of these delineated figures may ring kitsch alarm bells—or threaten, in fearful capitulation, to reject earlier (pre-World War I) innovations.

Once, I can't remember where or when, a critic accused Steven Spielberg's *Schindler's List* of being kitsch. I remember seconding this judgment. But I wouldn't agree if a killjoy shamed Picasso's neoclassical figures by calling them kitsch.

Picasso's line in 1922 and 1923, but not only in those years, offers a method of paying attention to human beings as not cargo, not corpse, not machine. Line, as Picasso handles it, has the status of lone remnant, of solitary vessel. Only line, among the ruined, remains standing. The surrounding white or gray fog threatens to obliterate the figure. You can call the fog beautiful, or you can ignore its grisaille. The fog condenses everything you will never

be able to name or to remember. The line—the last sur-
vivor, always the same—resists erasure, including the
erasure I might commit by deciding not to side with its
wiry or fat proclamations.

Picasso's line continues someone else's line; it doesn't
matter which forebear's line Picasso's line continues.

Picasso's line summons the sheer force of continua-
tion. The line speaks one thing; it speaks that we con-
tinue. (We continue to speak; like the Ancient Mariner,
or Dickinson's pale Reporter, we continue to tell.)

Picasso's line—whether in *Guernica*, *Man with Pipe*, or
Draped Nude Seated in an Armchair—speaks the absence of
color. Even when color exists, the line relishes color's sec-
ondariness, its irrelevance, its bracketed sick-day.

I'd meant to say, earlier, that I drafted this essay on
the day of my first colonoscopy, an exam I'd put off for
years, a procedure I should have undergone when I was
fifty, though I waited until fifty-four; I decided not to
mention the colonoscopy, not only because *colonoscopy*
is such an ugly word, at odds with Picasso's linear fi-
nesse, but also because I rhetorically over-rely on direct
witness—"odd secrets"—to juice up my argument or to
lend it a photorealistic urgency. A colonoscopy lacks sin-
gularity; possibly you have undergone or will eventually
undergo a colonoscopy, if you can boast the good for-
tune of living past the age of fifty, a temporal boundary
I once considered as pernicious and uncanny as the fact

that Egon Schiele died at twenty-eight years old, and that his ultimate drawing, done on the eve of his wife's death, and two or three days before his own, consists entirely of lines, quickly executed, in real time, with black chalk on paper, October 28, 1918.

Some of Schiele's lines seem smeared, edged by uncertainty; unlike Picasso's firm outline, Schiele's chalk lines participate in the unformed realm they depict the traveler embarking toward, even if the traveler doubts that formlessness is the direction toward which she has embarked, formlessness the shore her vessel is skirting, a conveyance hesitant to broach the mode of direct address.

Schiele's drawing attains eloquence not through line but through the line's liberal ability to *stop*.

The line depicting Edith's hand, as that line reaches southward to describe the arm, becomes merely one of those expressive curlicues underlying Klee's oft-circulated notion that a line is cognition out for a stroll; the line of dying Edith Schiele's collar, as it descends to describe her torso, becomes a smudge. Indeed, a line— when exercising its full freedom as an errancy fleeing captivity—can deliquesce into a smear.

I'd thought to begin this essay by mentioning my colonoscopy, but then I decided to avoid vulgarity; bringing up this unappetizing procedure would have the unfortunate side effect of asserting an equivalence between the alimentary canal—the colon's curves and involutions,

like involuntary memory's—and the written or drawn
line. I don't think that Picasso's line boils down to di-
gestive health or unhealth, or to the passage of food away
from form into formlessness, or the transformation—
the reverse sublation?—of food into garbage, into what
doesn't deserve to be said, seen, or thought. However, be-
cause I'm in the habit of including the events of the day
in whatever essay I happen to be writing, you see that in
this distended digression I have managed to include the
medical haruspication I'd decided it was vulgar to men-
tion, and I'm including this back-end divination because
the day of my "prep" for the procedure, a day of chicken
broth, Jell-O, and Gatorade, I killed time by imitating—
copying by hand—the drawings of Schiele and Alberto
Giacometti, paying special attention to places where their
lines deviate from delineation or accurate description.

While I'm dwelling within digression's hospitable
embrace, let me mention two books I recently absorbed,
two books that determined the tone and subject of my
present ruminations: the aforementioned *Medieval Modern*
by Alexander Nagel, and Georges Didi-Huberman's *Im-
ages in Spite of All: Four Photographs from Auschwitz*. I read
Didi-Huberman because Nagel cites him, and I decided
that I wanted to catch up on recent discussions that
approached with equal doses of anxiety and authority
the untimely, tenacious afterlife of images.

One of the four photographs analyzed by

Didi-Huberman, a photograph taken by a Jewish prisoner in Auschwitz, conveys, at first glance, very little information—simply a blur of trees and light.

Reading Didi-Huberman's sober treatment of these photographs—his argument for talking and writing about them, exhibiting them, continuing their operation of testimony—I found myself imagining a sacrilegious and unthinkable aesthetic procedure: I imagined abstracting from a photograph of trauma those formal aspects (angles, vanishing points, lines) that seemed irrelevant to historical testimony but that thrust themselves forward at me, their viewer, with a directness I can't gainsay. Extracting these formal substrata, I might turn them into paintings; or I might construct verbal arguments upon this borrowed fretwork, thus using the photo's formal données as scaffolding, upon which I'd build my own ephemeral, adjectival filigree.

By isolating these formal aspects I aimed not to aestheticize disaster but to observe form's capacity to carry on an articulation that opens another door in Being, a door unlabeled, though I doubt that it leads to quietism, indifference, or callousness.

4.

In the *New York Times* on the consecutive mornings of December 5 and December 6, 2012, I noticed two unrelated obituaries.

The obituary appearing on December 6 marked the death of architect Oscar Niemeyer at the inspiring age of 104. Alongside the death notice, the *Times* published a photo of the Oca Pavilion in Ibirapuera Park in São Paolo; this pavilion curves so flamboyantly that it rebuts linear hegemony (though we, as mature adults, certainly understand that a curved line qualifies as a line). Niemeyer's pavilion, turned by photography into a linear composition, like a Brancusi photograph of a Brancusi sculpture, must in real life appear so conical and curvaceous that a visitor would perceive the building not as linear but as rotund, like sculpted limbs.

One sentence in Niemeyer's obituary caught my line-dominated eye: "The design also heralded Mr. Niemeyer's war against the straight line, whose rigidity he saw as a kind of authoritarian constraint." Klee, partisan of deviation, posthumously concurs.

On December 5, 2012, the day before I read about Niemeyer's death, the newspaper published an obituary for Jack Brooks, "Former Texas Congressman," famous for standing behind Jacqueline Kennedy on Air Force One, November 22, 1963, post-assassination, as LBJ took the oath of presidency. The *Times* reprinted Cecil Stoughton's memorable photograph, so we could see traumatized Jackie, whose iconic face and grief-shocked posture obliterate the presence of everyone else in the photo.

This image, which I have examined intermittently
for decades, long ago involved itself in my brain's chem-
istry; this image dwells *inside* me, as a determinant,
however tiny, of my consciousness. On this photo, to a
minor extent, my percipience—my sense of being alive to
myself—hinges.

On December 5, 2012, however, when I resaw this
photo in the *Times*, once again marshaled for funereal
purposes, I realized that I'd never before noticed the
strong diagonal line of the airplane's inside door or
wall—a line that articulates movement toward a van-
ishing point, despite the cramped circumstances. No
verdant Tuscan prospect lies behind the bowed Mater
Dolorosa; instead, this photo thrusts us into the captivity
of a small plane, carrying more human cargo, and cargo
more aggrieved, than a lens can accommodate.

Jackie looms forward because the photographer looks
up to her from below; the strong diagonal line of the air-
plane's wall (or door?) surreptitiously leads the eye to
Jackie, and, with less emotional pungency, to LBJ.

As I considered mentioning this photograph, it oc-
curred to me that I'd need to face the consequences of
my argument, if my intimations and avoidances added up
to an argument; I'd need to come to a decision about the
relationship of trauma to formalism. *Formalism* is a heavy
word, too heavy to lift, too alluring to drop, too conten-
tious to leave unclarified. Call formalism my choice, as

viewer, interpreter, bricoleur, to highlight formal aspects of visual and verbal artifacts. Simply put: does formalism frame trauma? Does formalism enhance and construct trauma, or distract us from it? Must our decision to notice a line always qualify as a formalist gesture? Why, however, do lines, in a photograph attesting to a traumatic scene, seem to mobilize toward ends other than those, strictly speaking, of witness?

I'm always boxing myself into this same corner, this formalism versus ethics corner; I wonder if I'm the only person stuck in this cul-de-sac. I used to consider an invocation of Adorno to be sufficient to rescue me from this trap, but now I don't know what guiding spirit to invoke.

I think, for expediency's sake, I'll invoke Giacometti, not because he was a nice guy (James Lord's memoir, *A Giacometti Portrait*, depicts the master's exacting temperament), but because his drawings tirelessly use line for the sake of line. Perhaps his lines seek to escape—or to depict—a historical predicament; perhaps his lines materialize a spiritual vision, or delineate reality, or sublimate suffering. Indeed, Giacometti's line escapes, depicts, materializes, and delineates, but above all it wishes for continuity. Line, in Giacometti's hands, begs for extension—a state of amative, indebted congregation with all the other lineators in the history of the world, all the other lineators who have ever lived. Giacometti's lines, whether

they reach toward description of a figure, or toward de-
struction of a figure—Giacometti's lines, whether they
be form or *informe*—belong to everyone who came be-
fore and everyone who comes after. Giacometti's lines,
like pieces of candy that Félix González-Torres leaves
on the floor of a gallery or museum for strangers to take
away, embody freely traveling wishes. I refer to a sculp-
ture, *Untitled (Portrait of Ross in L.A.)*, 1991, composed of
a pile of "multicolored candies, individually wrapped in
cellophane"—according to the Art Institute of Chicago,
which will eventually own one version of this piece, if,
indeed, it can be owned.

González-Torres's work, a pile of freebies, literally
gave itself away, decomposed itself, as memorial to the
man whose death it marks, while Giacometti's drawings
enjoy the status of priceless originals, whatever the foul
and self-disregarding mood that overtook him in the
process of making them.

As always, at the end of an essay, I feel boxed in: here,
a false binary entraps me, a contest between perishable
and imperishable art, between art that consists in a sup-
posedly inimitable human trace, and art that traffics in
replaceable, machine-made parts. From this discursive
box, an exit door suddenly proposes itself: the line, in its
most individual iterations ("Just lost, when I was saved! /
Just felt the world go by!"), can take comfort in its se-
cret identity as a piece of replenishable candy. Where one

line came from, another line can be found; the factory of lines keeps operating perpetually, because all lines recapitulate and plunge again into the fountain of lines. All lines continue one line, and this fact does not diminish the line's happiness or individuality, but testifies to its negative capability, its comfort with losing identity. I like a line when I can say, looking at it, "I'm back, here, in the presence of a line. Lineation holds me again in its secure, continuous embrace."

Even a spiral or a wheel consists of lines. When Dickinson ends her "odd secrets of the line" poem by invoking a wheel—

> Next time, to tarry,
> While the Ages steal—
> Slow tramp the Centuries,
> And the Cycles wheel!

—she acknowledges that the line's odd secrets involve circularity and recirculation, cycling and recycling, an ecology of perpetual replenishment, perpetual relineation

The year in which I'm now writing, 2013, marks the hundredth anniversary of the first readymade, Marcel Duchamp's *Bicycle Wheel*, a piece described by the Museum of Modern Art as a "metal wheel mounted on [a] painted wood stool"; this dumbly resonant sculpture composes lines against its background. The piece,

though three-dimensional, attains clarity and "artiness" from the lines that it describes in space—as if the spokes of the wheel, and the legs of the chair, were lines writ by pen or brush on paper. Duchamp's *Bicycle Wheel* offers me the getaway vehicle I've awaited, the limo, or hearse, or speedboat, that can rescue me, a pale Reporter, a line hoarder, trapped in a rhetorical box with no Adorno to release me from captivity; in the nick of time, Duchamp's wheel cycles by, kindly stops for me, and I hop on its deathless circumference.

(2013)

MAKING MARKS

for Todd Shalom

We'll begin our walk at 441 East Ninth, right where
Frank O'Hara lived when he wrote his monumental
poem "Second Avenue," which opens with a startling,
enigmatic description of his own wild wish to turn *acts
of playful making* into the center of his life: "Quips and
players, seeming to vend astringency off hours, / cele
brate diced excesses and sardonics, mixing pleasures, /
as if proximity were staring at the margin of a plea. . . ."
We will behave like quips, like players. While walking,
participants will write, draw, talk, and accumulate—
mixing pleasures and celebrating excess. We'll experi
ment by making spontaneous marks of our ruminations
and observations, whether with pencil, pen, stick, stone,
scrap, spit, or other found (and offered) substances. Our
goal: to liberate and unhouse our repertoires of verbal
and visual markmaking. In the process, we'll compose

a document (or a bagful of documents) to take home afterward and keep as a record of our adventure.

✦

Each walker receives a Canson "Mix Media" art pad, as well as a selection of pens, colored markers, watercolor pencils, and other simple materials. The focus of the walk is the pad, its sheets separable and sturdy.

✦

To summon energy, begin with a resonance exercise: find a note, hum it, feel the vibration in your nose, cheeks, and lips.

✦

During the next ninety minutes, make as many marks as possible. A few of them will be ones that you love and that will inspire a new direction in your aesthetic life.

✦

Stand in front of (or near) the apartment building where Frank O'Hara once lived, on the north side of East Ninth Street, between Avenue A and First Avenue. On

your pad, make an identity mark—a mark that signifies your identity or attests to your existence.

✦

Find an event on the ground, on a wall, or on a building's surface; with a mark on your pad, acknowledge the event. Find two events juxtaposed, and interpret the juxtaposition.

✦

Close your eyes, experience the air, the temperature, and then make a mark to acknowledge this atmosphere.

✦

Walk a few paces and stop when you see a color that you like; acknowledge the color with a mark.

✦

Write down the name of a person who represents the great unconsummated, unreciprocated, or shattered romance of your life—then surround that name with a series of very messy marks, or otherwise commemorate that person with whatever marks you choose to make.

✦

Make an untidy mark. Make several ungoverned marks. Spit on your page.

✦

Write while walking, with your eyes open.

✦

Draw a grid. Look at the sky, find an event to draw or describe, and mark it on top of the grid.

✦

What did you dream last night? Mark it.

✦

Write a criticism of a mark you've made today. Write a note of praise for a mark you've made today.

✦

Which dead people do you feel are present—or should be present—on East Ninth Street with us now?

✦

Moisten the page—do you have a water bottle you can dribble on the pad?—and then drag a watercolor pencil through the puddle.

✦

Write or draw something impermissible with a watercolor pencil. Efface the marks with water. Retrace the effaced marks, or write something new on top of the smudge.

✦

Cross Avenue A and enter Tompkins Square Park. Find a partner. Sit together on a bench and take turns being the speaker. While the first speaker engages in a monologue (about any subject whatsoever), the partner should make marks of response, transcription, or counterpoint. Then, trade roles: the formerly silent partner engages in a monologue, while the formerly vocal partner silently transcribes or makes marks in oblique response.

✦

Write a three-minute novel about what took place on this cubit of earth, one hundred years ago.

✦

Make a mark on someone else's pad.

✦

Hunt for omens that will catalyze or predict the directions your creative endeavors will take in the coming year. We turn an espied detail into an omen by overinvesting in it, overinterpreting it. Surplus cathexis ennobles the detail and makes it an omen. That's why we're walking tonight: to ennoble. Are there omens in the flower bed?

✦

We gather now at a fence in the park. Using a bit of available glue, we affix one or more of our pages to a significant position on this fence, a position that has meaning for you, however slight and phantasmal. This arrangement of pages constitutes our pop-up exhibition in honor of Frank O'Hara's "Second Avenue," a dense litany that ends "'You've reached the enormous summit of passion / which is immobility forging an entrail from the pure obstruction of the air.'" You may never reach that summit; enjoy, meanwhile, the obstructions, pure or impure.

(2015)

"MY" MASCULINITY REMIX

I.

In 1994, I wrote a short essay called "'My' Masculinity." Twenty-two years later, I revoke my earlier version and start the composition all over again. (Consider the two essays mismatched nipples.) Did anyone own masculinity in 1994? Aren't we finished with possessiveness—its sodden betrayals, its puerilities, its cuts?

2.

I only half-mean what I say; identity remains in the half-meaning, the ruse I fall into when I begin this odd dance called thinking. I don't have an identity, only

a vast fatigue—
did I once call it
a vast *summational*
fatigue (but what
am I summoning
when I say "summational")?

3.

Summing up is the enemy of staggered discovery, and yet I feel nostalgia for thinkers, like Siegfried Kracauer, who confidently strike final poses: "Like emigrants gathering up their personal belongings, bourgeois literature gathers the effects of a household that will soon have to vacate its current site." Vacated up the wazoo, I seek new justifications for piecemeal introspection—methods for germinating a thought and then splitting the thought in half, as if the idea-morsel were to greet or devour itself. Vulnerability to self-division is a sufficiently stable platform for speech.

4.

A house on a
horizon line has no
interest in adjudicating
debates. But we
are not a house,
we are a petty
adjudicator.

5.

"can I do this spiritual drag, collective agony wishful thinking," wrote kari edwards. I, too, wonder if I can do this drag of speaking or thinking collectively, drag of not being singular, drag of shedding the rags of self.

Adrienne Rich once excoriated these rags as "personal weather." She opposed personal weather to "the great dark birds of history." Syllables shamed by birds of history can intoxicate the ear. Remix, please, a consciousness, nominally mine, governed by its enthrallments, and hell-bent on squeezing cadence out of thrall.

6.

Few poets today can rival the unstoppered perversity and brilliant heedlessness of Ronaldo V. Wilson. Seeking shelter from the brutal weather of the normative, I turn to his book *Farther Traveler* (2015) for the comfort that only extreme language about extreme situations can give. From his poem "Multiply": "Banged by 29 men, and you wanted some of them, / the red-ape, monstrous heaving, then sleep, / to wake, to be that cum bucket, filled." I repeat, as an under-the-breath mantra, the words "cum bucket." How can I express strongly enough to you the quietude that arrives by repeating "cum bucket" and delving into its sonic riches, the "u" and the "u," twinned vowels, an effect I was taught to call *assonance?*

7.

Percy Bysshe Shelley's masochistic stances are a sweetly Christological template for cum-bucket consciousness— as when he writes (in the 1819 *Prometheus Unbound,* that proof-text of thralldom's occasional potential to become

exalted flight), "Insufferable might! / God! spare me! I sustain not the quick flames, / The penetrating presence . . ." Maybe Percy is impersonating a water goddess. An imploration arises from one person's voice, but then the words acquire naughty, independent life, apart from their originator. *I sustain not the quick flames* is a phrase that fits any circumstance, any occasion in which you wish to assert ambivalence. *I sustain not*—nearly oxymoronic—asserts the possibility of sustaining antitheses, of preserving antiphonal cacophonies.

<div align="center">8.</div>

Saw Nicola Tyson monoprint portraits today in New York at Petzel Gallery uptown. She painted them more than a decade ago. A decade ago I didn't know what a monoprint was. How could I claim to know what genders were, if I didn't understand monoprints? Tyson's procedure: paint a glass plate, and then press a piece of paper onto the wet original, which feeds its colorful essence to the recipient. The result is smashed identity. Try to figure out who someone is, from a Tyson monoprint, and you'll discover a lump instead of an identity. When I say "I," when I say "my," I am behaving like a fruitfully messy lump. A monoprinter passes identity through baptismal mediation. Dunk a self into the acrylic fount, and then drag out the remnants, unrecognizable, from the gunky morass.

9.

In some of Tyson's large graphite and ink drawings (of tall skinny women?), I perhaps delusionally note the motif—near the pubic area—of a bone or codpiece, a tiny curiosity protruding or hanging down. Its nonbinary oddity amuses and educates. I might be imagining this flashdrive bone chip, a glad specter near the groin. Graphite and ink, in Tyson's expert hands, aren't just servants of her subject; these materials become agents of change—of rippling, unsettling motion.

10.

I like to exaggerate the elements of feverishness that exist within motionless artworks. Adam McEwen's spartan graphite sculptures (of, say, mainframe computers) contain a secretly febrile enchantment, as if ideas rippled, bubbled, and wept inside the graphite mass. This strategy I advise you to learn: figure out how to find the latently febrile tendencies lurking within reticent quiescences. A toilet bowl plunger qualifies as a quiescence.

11.

Anne Collier's photo series *Women Crying* (2016), at Anton Kern Gallery, set me thinking about crying. *Women Crying.* W. C. Water closet? In Collier's provocative acts of conceptual, emotional, and optical destabilization, copying intrudes. We welcome intrusions. Intrusions

complicate our otherwise claustral existence. To wit: in one photograph, a pair of hands (a woman's?) holds a movie soundtrack album, *For Whom the Bell Tolls*. Its cover is a close-up image of Ingrid Bergman's tearful face. Another Collier C-print depicts a record cover with a more extreme close-up of Bergman; this LP, however, is an album called *Men*, by the "noise/grind/metal/what-the-fuck" band Burmese. Were Burmese's members Burmese? Questions—needling, digressive—are not a tic; they are a tactic.

12.

Boys Don't Cry (1999) is a movie about the murder of trans man Brandon Teena. I don't cry. My boycott against crying is complicated. "My" masculinity can be found somewhere between Ed Ruscha's *Twentysix Gasoline Stations* (1963) and Collier's *Women Crying*. (The metaphoric chain connecting these two photographic series includes tear gas.) In rigorous and in fanciful aesthetic procedures begins the replenishment—through critique, through reenactment, through ritual, through kicky if sober-seeming *détournements*—of depleted resources.

13.

If a secret agent wanted to find the historical residues of rigorously fey critique, this private eye might investigate the paintings of Hernan Bas (in a 2016 exhibition called

Bright Young Things at Lehmann Maupin Gallery in New York); these paintings could teach the ferreting spy that "my" masculinity got lost—or materialized—or struck bottom—in the fin de siècle. Acrylic, the medium Bas reclaimed for these works, came of age in the 1950s. Bas's acrylic marks look like oil (and indeed he sometimes incorporates colored pencil, chalk, and oil pastel); his colors are more cheerful, more superficial, than exclusive use of oil would allow. Secret superficiality camouflaged as oily depth permits the merriment of identity's dissolution to surface, like bubbles above a sludge ellipse. See shredded pieces of "mine" and "my" disappear down the flushed toilet.

14.

Went this morning to the Bowery's New Museum to absorb Cheryl Donegan's alert interpretation of how gender gets confused when it collides with middlebrow design. I stole the phrase "middlebrow design" from the exhibit's succinct wall-text. Middlebrow design is where masculinity (mine, yours, ours, hers, theirs) forgets what to do with itself and considers this memory lapse or misrecognition (*Am I masculine? Was I masculine? Will I be masculine tomorrow?*) to be a new form of tepid exaltation—the tepidity itself the source of the excitement. Femininity, too, gets screwy, mine and his and yours, when it hits middlebrow design's sober practicalities. I don't

know what middlebrow design is, but I wear it, create it, cruise it; it creams all over me. Three gas-mask fashion helmets (re-creations of chic headgear that appeared in Donegan's *The Janice Tapes* [2000]) are not for sale, but I wanted to buy them in the exhibit's smart and seductive *Concept Store* installation. Hanging out at the shop's computer-monitor screen, I clicked on a pill-shaped ellipse because it said click me, even though nothing happened when I clicked. Nonetheless, I kept doing it, and enjoyed the experience of the repeated, futile click.

15.

Confronting two of Donegan's videos, *Channeling in 5 Versions* (2001) and *File* (2003), projected simultaneously one above the other, I stood mesmerized by the card-shuffled bricolage of middlebrow fabrics, maybe low- and highbrow ones, too. (Who can tell them apart?) The quick-splice rhythm prepared me, on my walk home afterward, to ford the city's phantasmagorical battalion of rectangles and curves and in-betweens, squares and lines and triangles and parallelograms and unclassifiable other shapes—none of the tesserae precious because someone authorized them to be precious, but precious because an eye (Donegan's, and now, mine) had found a way to thrive within the nonce category of *fabric that has no longer any purpose, fabric that now signifies dizziness itself.* Fabrics become paintings; three-dimensional scenes get

compressed and reborn through virtual technologies, and we learn to live and love inside these compressed spaces—learn to treat compression as elixir, just as lyric poetry, not to mention sublimation, long ago taught certain souls to do. In the last twenty years, I've learned that becoming dizzy, and learning how to become *educated by dizziness*, are worthwhile callings.

<p style="text-align:center">16.</p>

And then, this evening, wanting to change my mind about most claims I've made, I wrote:

try to say
something lucid
and small about
the papery
quality of daffodils—

If that clause isn't lucid enough, or doesn't sharply retract the regime of false certitude, please substitute, for the word *daffodils*, another noun, any noun that will help you get through the night.

<p style="text-align:right">(2016)</p>

THE PORN PUNCTUM

In a porn photo, the punctum is the detail that does *not* arouse. It neutralizes desire, and by that act of clemency, of numbing surcease, surreptitiously reinstates and intensifies passion. As devotees of porn, we request the real, not the fictive; we want to verify the depicted scene. The narcotic bath in which we steep, while savoring a porn photo, consists of nonsexual details that are concupiscence's underpainting, the unsuspected colors (ultramarine, burnt umber, alizarin crimson) that secretly give the figure its conspicuous liveliness.

✦

A paradox: the porn punctum catalyzes and reprieves desire. Reprieve takes the form of anesthesia. Eroticism needs the punctum that undermines physical self-surety and thereby keeps sex the variegated, error-strewn landscape that we restlessly crave.

✦

A shower curtain with blue and black polka dots. A plastic hanger. A yellow ochre terry-cloth bath towel. A wooden chair. The dick not very big. A black rectangular butt-plug and a rolled-up pair of blue Levi's. A bright orange teddy bear, next to a cactus in a plastic brown planter. An unduly thick penis. A square face with black horn-rims. Behind an endowed man, a wastepaper basket. A CD rack. A bottle of Sprite. A shaved pubis. A floral-patterned throw pillow. Auto-fellatio on an orange suede rug. Pinned to the wall, a photograph of marine coral. A washing machine. Dirt flecks (or moles?) on a model's legs. A necklace-suspended silver cross, lodged between a large man's breasts. Puckers of a ruched curtain. A leafy circlet around a lampshade.

✦

The porn punctum distracts me from desiring the nude body. I can't get turned on if I'm focusing on the polka-dotted shower curtain. False. I'm more aroused by the shower curtain than by the fornicating guys. I desire the *counterpoint* between eroticism and decor. The clash of discourses—cock, shower curtain—creates a psychological and somatic friction, a dissonance that offers density, strangeness, and sorrow. Melancholy may be sexuality's unwanted supplement, or its beseeched-for authorization stamp.

✦

The porn punctum provides a glaze of reality, like a cleaning fluid sprayed on wooden furniture to assist the polisher and make sure the surfaces shine. In my youth, a popular product was Lemon Pledge. What did it pledge? Lemon Pledge arouses me more keenly than the sexual scenes it varnishes.

✦

The liminal balustrade I lean on, when gazing at an arousing photograph, is the porn punctum: the inert zone, the never-brutal carpet, the pacifist drapes. Drapes and carpet save me from tumbling into a libidinal abyss. I beg the punctum to keep me separate from an engulfing, chthonic eroticism.

✦

A buff-white shag carpet, its nubs not elegant. Gray-checked bedsheets, and a matching pillowcase. Behind his erect penis, a ficus plant. Feet resting on a rattan laundry hamper. Jockstrap with a pewter-gray band. Three white trucks parked in a dark lot. A spoon resting on a park bench. The yellow lid of a garbage can. In a shower stall, a naked man posed beside a sign: MASTURBATION IN

THE SHOWERS IS A VIOLATION OF THE UNIVERSITY OF MASSACHUSETTS HOUSING CODE. THE SHOWER DRAINS ARE NOT DESIGNED TO HANDLE SEMEN! THE EXCESSIVE AMOUNTS OF SEMEN IN THE DRAINS CAUSE THOUSANDS OF DOLLARS IN MAINTENANCE AND REPAIR. Five seagulls perched behind a sunbathing man on a sandy beach. A cock ring and an ironing board. Torn undershorts. An unfastened seat belt. A map of Washington, D.C. A naked man reading his cell phone's screen. A wall-mounted wine rack containing only one bottle.

(2017)

THE TASK OF THE TRANSLATOR

Daisy was a poet; Gavin, a translator; Wayne, a teacher.

Gavin translated Daisy's poems, poorly, into English.

Wayne taught the inaccurate translations' deeply creased interstices.

Sometimes Gavin added meanings of his own.

Wayne taught these supplemental innuendos.

Daisy and Gavin were too young to remember the previous war.

Wayne invited Daisy and Gavin to visit his seminar and discuss translation's perils.

Daisy had an accident in the seminar. She broke down crying. Gavin tried to comfort her. Wayne vowed never again to teach Daisy's cloudy originals.

✦

Gavin and Daisy began having an affair.

Wayne changed his mind. He invited Daisy back to the seminar, despite her breakdown.

The seminar took place in a dungeon. Troublemaker Daisy read her originals into a distorting, crackly amplification system, which made the words more desirable.

✦

Gavin made great money by translating Daisy, a star of underground cinema.

Wayne made a decent living by teaching Gavin's translations. Secretly Wayne wanted a direct erotic friendship with Daisy, but he settled for Gavin.

Wayne and Gavin always met for beers before class, so they could talk about Daisy's opacities.

Daisy was the genius, Gavin the conversationalist.

Gavin tried to translate breakdown. He grew exaggerated sideburns and wore tinted glasses. Daisy wore hippie skirts. Wayne taught the skirts and the translations, the originals and the sideburns.

✦

Despite his relative affluence, Gavin lived at the Y. Daisy lived at the Waldorf.

Daisy thought her originals were flameproof, so she set fire to them in her ice bucket. A bellboy put out the flame. Daisy faxed the charred fragments to Gavin, who

translated them. Wayne taught the remains. Daisy's finger felt the wound.

✦

Wayne took Daisy out for a drink. Gavin came along, to translate. Only Gavin could master Daisy's demanding multiplicity of dialects. The three friends ordered a plate of clattering mussels.

"Teach my originals," said Daisy, to Wayne, who shot Gavin a complicit look.

"You're a genius but I value my life," Wayne told Daisy.

"My loss is untranslatable," said Daisy, through Gavin. "And my finger hurts."

✦

Then everything changed. Gavin discovered his voice. Daisy lost hers. Gavin became an original, and Daisy translated him.

Meanwhile, Wayne taught himself the rudiments of Daisy's language, a newfangled combination of several dispersed tongues.

Before class, Wayne and Daisy went out for beers to discuss Gavin's originals. Gavin wanted to come along,

but Gavin, now that he was an original, had become untrustworthy, unsavory. As Wayne enveloped himself in Daisy's hippie skirts, the notion of the uncapturable trace came alive for him as never before.

✦

Daisy and Gavin resumed their affair and videotaped themselves having sex. Wayne watched the videos. A torrential mess. Attractive. For sale. Dispersed remains. Daisy got her voice back and Gavin lost his. Gavin returned to translation, and Daisy to originality. Militant divisions. Everything reverted to normal.

✦

Daisy wrote a poem about the imminent war. Gavin refused to translate it. He said it violated her contract. War changes the contract, Daisy argued. Gavin took off his shorts.

✦

Daisy had biblical patches. Gavin's duty was to seek out the patches and remedy them, disguise their purple.

In their sex videos, Gavin and Daisy nude-wrestled, their bodies slick with the infantile.

Daisy and Gavin were still in their twenties. Their work had hardly begun. It was a pity that one of them would soon die.

✦

Daisy sounded like Francis Ponge, Nazim Hikmet, and Marina Tsvetaeva, but Gavin distorted her in translation, turning her into a bargain-basement Paul Verlaine. He infelicitously translated Daisy's famous poem about a pebble. Wayne caught the errors but didn't dare tell Daisy that translation had soiled her pebble original.

✦

Against advice, Wayne showed his students the video of Gavin and Daisy nude-wrestling. Assignment: write a paragraph adjudicating the fight. The students en masse said they hated allegory. They refused to write the paragraphs. The twentieth century ended. The war began. Wayne wrote a paragraph. He brought his allegory to the bar and discussed it with Gavin, before class, while they drank beers. Gavin's alcoholism got worse, almost rising to Daisy's level.

✦

Daisy decided to take a shower before she wrote another poem about a pebble. She shampooed with Herbal Essence. Gavin joined her in the shower, put conditioner in her hair. Wayne opened the bathroom door. "Can I come in?" he asked. Gavin said yes. Daisy said, "Please don't use your video camera." Gavin refused to translate. Wayne had forgotten his rudimentary knowledge of Daisy's vernacular. "Gavin," said Wayne, "do you mind if I video?" "That's fine," said Gavin. "I'm sick," said Daisy, "of Wayne's feeble literalism."

✦

And here are Daisy and Gavin, at the Oscars!

Daisy was nominated for best foreign original, and Gavin was nominated for best translation of a foreign original.

The winners are—Glenn Close opened the envelope—Daisy and Gavin! The theme music of the Daisy and Gavin movie began to play, and Daisy and Gavin walked onstage together to accept their Oscar, a conjoined-twin statuette, two selves united at the rib cage. Afterward, downtown, Daisy and Gavin found a practitioner to bisect (illegal operation) the monstrous Oscar.

✦

Gavin got a lot of translation work for high prices because he was exceptionally handsome. Daisy's pebble poems were praised because she was beautiful. Gavin got sexier, after the Oscar. Daisy got dumpy. Now Daisy was jealous of Gavin, his face on magazine covers. The translator and his sideburns. The translator and his room at the Y. A curious nation's shifting population watched Daisy and Gavin vie.

✦

Then Wayne and Gavin started having an affair, and Wayne checked into the Y, to be closer to Gavin. After sex, Wayne and Gavin went to the coffee shop across from the Y, to discuss Daisy's originals. Gavin's body improved, the longer the affair lasted.

Daisy continued to write further installments of her pebble poem. Gavin, at the coffee shop across from the Y, discussed the new translations with Wayne. Tonight Wayne was teaching the seven hundredth poem about the pebble, and Gavin couldn't explain a few of the nuances. "If I don't understand the pebble, Gavin, I can't teach this poem," Wayne said, exasperated, as he ate his hamburger and drank his malted milk.

"We go about the tasks of daily life," said Gavin, "in our own ways."

"Your translation is more confusing than the original," said Wayne.

Shocked, Gavin gripped the edge of the table. He froze and fell backward in time to a moment before he'd begun to translate.

✦

Daisy's new project was a revision of Fernando Pessoa's *The Book of Disquiet*. Daisy called her version *The Book of Perpetual Quiet*. Gavin had already begun to translate it, though Daisy had not finished writing it. Gavin worried that Daisy was not composing quickly enough. Wayne worried that Gavin was not translating quickly enough. Over beers, Gavin told Wayne that Daisy's *Book of Perpetual Quiet* was her most difficult work and the most exasperating to translate. Wayne replied that the task of the translator was to stop complaining. To escape the day's cruxes, the teacher reached his hand into the translator's pants.

✦

"Every act of speech is site-specific," Gavin told Daisy. Wayne was filming their conversation with his video camera so he could replay the event to his class. Wayne worried that Daisy's and Gavin's nudity would offend students.

The students were not offended. They applauded Daisy's and Gavin's bodies.

"In Daisy's pebble poems," said Wayne, to his seminar, "she is totally 'out there.'" Gavin, visiting the seminar, interrupted. "I disagree. In my translations of the pebble poem, I show that Daisy is completely grounded. That's the point of the pebble: to demonstrate Daisy's connection to diurnal things." Daisy was sitting at the other end of the conference table. She wore a pink wig today. She still had a wound on her right index finger, from the Waldorf ice-bucket flame. Despite discomfort, Daisy took notes. Her new fluency in English surprised everyone. She was outgrowing the need for a translator. This fact upset her. She'd acquired clout in the literary community because she relied on a translator. Originals were respected only if they passed through translation's veils. "I miss my power," Daisy whispered to herself, in the seminar. As she contemplated her vanishing clout, she began to cry. Georgie, a student who had a crush on Gavin and was doing a video documentary about him, began to film Daisy crying. Any exploitative footage was fodder. "I'm pissed," whispered Daisy, as Georgie filmed. "I'm pissed that the teacher doesn't get my pebble nuances."

✦

The task of the teacher is to translate.

The task of the translator is to wake up Daisy.

Daisy's pebble nuance poem is the translation of the burn.

The translator is the task of Daisy.

Gavin is the Daisy of Wayne.

The Waldorf is the translation of the Y.

The Y is the Waldorf of the translator.

The burn is the nuance of the pebble.

The task is the dispersal of the translator.

Gavin is the Oscar of the pebble nuance poem.

The seminar is the task of the burn.

The breakdown is the Oscar of the task.

The sexual fantasy is the task of the Y.

The breakdown of the translator is the task.

The seminar is the sexual fantasy of the translator.

✦

Multiple choice quiz:

1. War is
 (a) the task of the translator
 (b) outside the story
 (c) the story
 (d) untranslatable
 (e) all of the above

2. The task is
 (a) the translator
 (b) Daisy and Gavin's sexual incompatibility
 (c) Daisy's sexual voraciousness
 (d) Gavin's sexual hang-ups
 (e) how we got here and how we get out of here

3. Shame is the tint of
 (a) the translator
 (b) the task
 (c) Daisy
 (d) the pebble nuance poem
 (e) untranslatability

✦

Spleen
a new poem by Daisy, translated by Gavin

Daisy, grand flotation device,
loves the pale inhabitants of the nearby cemetery
that pours mortality on the smoky suburbs.

Daisy on the roadside looks for litter
agitated without rest by the meager galette
that Gavin fed me when I tried to strangle his gullet
with my sad voice, all frill and phantom.

My pebble burden is perpetual mouth, lamentation
faucet that never turns off,
rheumatic dependency, foul ball, perfumed yard-sale.

Heritage is fatal, said Gavin, in the Waldorf,
under a hydroponic umbrella. The handsome valet
offered to undo my pique by sinisterly causing

my translatability to go falsetto.

✦

In the dungeon, Wayne taught Gavin's translation of
Daisy's "Spleen." Daisy attended the seminar. Her burn
filled the room. The war began. Would we win was not
the question. The question was how to translate the pro-
noun *we*.

✦

"I don't want merely to fall back on rhetoric," Daisy said
to the seminar on the second evening of the war. *Daisy's
voice is newly transparent in the evening*, thought Gavin, afraid
of being erased by evening. Wayne was trying to teach the
students about Gavin's fear of erasure and about Daisy's
new wartime transparency. "Tasks can't go on as usual,"
said Daisy to the room, but the room didn't trust her,

because she was having another florid breakdown, carefully documented in the pebble nuance poem. Gavin was taking notes for a future translation of Daisy's in-class breakdown on the second evening of the war. Wayne was trying to teach Gavin's future notes, even before they were written down or translated, and this precipitousness, this earliness, was posing problems, complications to be discussed between teacher and translator, later, at the Y, in Gavin's room, after Daisy had returned to the Waldorf.

◆

Scarlatti wrote 600 sonatas, Daisy wrote in a poem that Gavin was trying to translate and that Wayne was trying to teach even before it had been translated; *Scarlatti wrote more than 600 sonatas, and at his death*, wrote Daisy, in a poem that expanded on the work of the pebble nuance poem, *Scarlatti's manuscripts were dispersed, and his reputation fell into obscurity*. Gavin translated the lines poorly, but Wayne could see through the inadequate wording and in any case no longer taught translations, only originals. In the seminar, Gavin applied a bandage to Daisy's burned finger. In wartime it was prudent to teach only originals, but no one in the seminar, including the teacher, fully understood Daisy's amalgam of tongues, or the sources of her wounds, or if her losses had origins.

✦

Ars Poetica
a new poem by Daisy, translated by Gavin

Music comes first.
I prefer impairment.
The vaguer and airier, the better.
Less pizzicato, more posing.

It's also necessary to wander from the point
and to choose your words contemptuously
so you don't end up behaving like a grisette
in a derision joint near the indecisive Rhine.

O beautiful derrière of Gavin, translating me!
O beautiful trembling day, nearly noon,
above autumn's accidents, the Kremlin
framing Daisy's love for Gavin's oyster-clear eyes!

Voilà, nuance, come, again and again,
into my pebble poem, colored red or yellow
according to my fiancé's whim—
I hop from dream to dream like a flute having a
 coronary

and I try to assassinate—
good Daisy that I am—every impure thought,
every "point," every cruel azure argument

you can take your elegance, Gavin,
and shove it up your ass! feral
Being, assuaged by rhyme,
veiled by the Almost, the Nearly—

I'll sue you, rather than step
forged into the lime-bright falseness of this age,

musical as the Aga Khan though no one cares,
enveloped by agency
and within the alleys of your decisiveness
arguing a footpath between brother and other.

Good luck, Gavin,
I'm parsing you as best I can.
The bed you sleep in isn't literature's.

◆

Next year, Gavin and Daisy were nominated for Oscars
again—Daisy, for best foreign original, and Gavin, for best
translation of a foreign original. Daisy lost. Gavin won.

Gavin had carefully crafted an acceptance speech, which he read aloud to the gathered crowd. After reading it, onstage, he shot himself in the heart. Daisy, in the audience, ran up to him and threw her living body over his dead one. The next week, Wayne taught Gavin's acceptance speech in his translation seminar. Here is the speech in its entirety:

"Translation, like triumph, is a subject I can approach only cautiously. If I had a language other than my own, perhaps I could broach this subject, and this imperial occasion, with more fortitude and clarity; in the absence of a substitute language, I must regard this subject as one too daunting to trifle with, too large to avoid. Lucky indeed am I to be in the position of speaking to you today about this matter, a matter I shall call the opposite of weightless, a matter unapproachable despite my surprising victory; for today's occasion, untranslatable, proposes a subject before which any thinking and feeling woman or man, any woman or man with a sense of historical consequence, must tremble; a subject before which we must take unusual pains, lest we damage ourselves or our listeners by mishandling a single nuance of the burden I would not call *word-hauntedness* if there were a better noun in my forlorn and bewildered language to describe the task."

(2003)

III

PUNCTUATION

1.

These cold spring days, I've been ruminating about punctuation. Evasion of facts? Flight into formalism? Culpable immaturity? Should I stop paying attention to interruptions? Start focusing instead on history?

Hannah Arendt gives me pause. A solid, ethical writer, she uses dashes to set off parenthetical expressions. Listen: "And the acceptance of privileged categories—German Jews as against Polish Jews, war veterans and decorated Jews as against ordinary Jews, families whose ancestors were German-born as against recently naturalized citizens, etc.—had been the beginning of the moral collapse of respectable Jewish society." A dash offers a place for holding your breath, while the weight of parenthetical information, subordinate yet urgent, lands on top of your body.

2.

I have a problem knowing when to pause. I catapult into irresponsible acts. As a schoolchild, never raising my

hand before speaking, I battered the classroom air with questions. For that tendency, I acquired a nickname: Question Bomb.

Walter Benjamin, a fellow Question Bomb, tried to answer some of the questions he posed. I'm not sure he answered them to the satisfaction of his stringent landsman Theodor Adorno, who berated Walter for insufficiently dialectical thinking. Here is one of the culpable questions Benjamin posed: "*Was ist Aura?*" He inscribed this riddle on a strange piece of stationery (labeled Manuscript No. 221 in his archive); the page is crowned with an advertising image of a San Pellegrino water bottle. Perhaps Benjamin is addressing his open-ended question—*Was ist Aura?*—to the bottle itself. What is your aura, San Pellegrino, patron saint of the unwell?

3.

My happiest moments as writer and reader occur in the space around the period. Retroactive fixity suddenly enshrouds the sentence, as we look back on it; we can understand what it tried to mean, what it failed to say. We can forgive its incoherences.

Short sentences put me in a good mood. So does self-laceration, when artful. Two short sentences from E. M. Cioran suffice to remind me that brevity is a calling:

"Cristina Ebner lived from 1277 to 1355. The Middle Ages were pregnant with God." Christina dreamt that she gave birth to Jesus Christ. Recently I used the word *epidural* to describe the moment when nervous cerebration was forced to stop.

4.

Marguerite Duras was full of mannerism but also wished to detach herself from posing. Her sentences tear themselves apart before they can achieve assembly. In an interview, she confesses a desire "to tear what has gone before to pieces." She describes one of her books, *Destroy, She Said*, as devoid of sentences: "I don't think there are any sentences left in it." We destroy sentences to banish style's encumbrances. As a reader, I seek sentences that reveal—in their method, not merely in their meaning—a core of self-destructiveness.

5.

Annie Ernaux, like Duras, prefers the piecemeal. And though Ernaux begins her autofiction *Shame* with an arresting sentence that seems to announce a traumatic cause, she devotes her short book to tangling catalyst and consequence, so that events no longer leave reliable footprints. Her opening sentence: "My father tried to kill my mother one Sunday in June, in the early afternoon." A short sentence, the kind I like. We're never too far from

the period. We can see it coming. Each of us is loaded, like a gun, with bullets like this sentence, bullets we'll never fire. I went through a phase, as writer, when I could give information only laconically. I made the mistake of considering my unemotional remoteness a style, and therefore seductive. I've often fallen into the trap of considering my self-administered epidurals (figuratively speaking) to be powerful flirtation tools. I'll wipe out all feeling from my voice, in the hope of luring you to fall in love with me.

6.

Being spellbindable is my fate. This mesmerized state is one that Denis Diderot considered ideal for viewers of paintings. In fact, it was a painting's responsibility to spellbind its viewer, according to Michael Fried, who paraphrases Diderot's credo as follows: "a painting, it was claimed, had first to attract (*attirer, appeller*) and then to arrest (*arrêter*) and finally to enthrall (*attacher*) the beholder, that is, a painting had to call someone, bring him to a halt in front of itself, and hold him there as if spellbound and unable to move." After the word *beholder*, Fried uses a comma, but I'd prefer a semicolon.

Situations of extreme jealousy cause me to freeze—to become spellbound. In the early 1970s, a teacher temporarily considered me her favorite student. But then another student—call him Moses—became her pet. During

recess, I saw this teacher and her new protégé enmeshed in a conversation I tried to join. The teacher said, "Moses and I need to be alone; we're having a private talk." Her words arrested me. I heard them as a call—a summons to become ice. I hugged the spellbound sensation to myself, as a new, strange possession—a capacity to become cold.

7.

Daniel, a dashing young man who works at my neighborhood's art supply store, sent me an email. His last words in the message were "Later homes." "Later homes" was a complete sentence, though it baffled me. I looked up *homes* in a slang dictionary. *Homes* means friend or acquaintance. *Later* means "see you later." Ideally, Daniel would have put a comma after "Later." Later comma homes. His opening words, in the email, were "what's up dude." *Dude* spellbinds me; the word calls me straight, presumes me a fellow dude, friend to Daniel, who is probably straight, though his wish to have a drink with me gives me hope that he is complicated. To tell you this story without describing Daniel's face is to commit a sacrilege against the gods of narrative, who decree that every meaning—every emblem—must be composed of an image and its caption. Daniel can function as an allegory only if I describe his face. Otherwise he is merely a caption.

Milton Avery's paintings arrive without captions and without the wish for a caption. Clement Greenberg, in *Art and Culture*, does a manful job of capturing what makes Avery's art so spellbinding—its exactness. Exact without being fussy or bossy. Exactitude *without tears*, as Johnson & Johnson Baby Shampoo famously promised, in an ad campaign that interfused itself with my earliest ventures in nude bathing, which took place, naturally, in my childhood home's bathtub, under the watchful eye of my father, who administered the potion with what I would like to remember as a liberal hand. Listen to Clement Greenberg salute Avery's unmodish exactitude: "The question has to do with exactly how Avery locks his flat, lambent planes together; with the *exact* dosage of light in his colors (all of which seem to have some admixture of white); with *exactly* how he manages to keep his pictures cool in key even when using the warmest hues; with *exactly* how he inflects planes into depth without shading, and so on." Greenberg italicizes the repeated words *exact* and *exactly*. Exactitude sticks out from the page. Exactitude consists in a decisive parsimoniousness: not serving the viewer too much food, not overpouring the drink. Greenberg hides his heat within cranky sentences. I won't call them barren, because they contain thorns, and a thorn promises, eventually, a rose. Behold Greenberg's thorn: "I still quarrel with Avery's figure pieces, or at least with most of them. Too often their design fails to be total."

8.

To fail at totality! I went through a phase, a few years ago, of reading philosophy. I didn't make it very far, however, through Hegel's *Phenomenology of Spirit*. I stopped after finishing the preface, subtitled "On Scientific Cognition." My time for reading Hegel will come. *Cognition*, after all, is one of my favorite words. And was not the spellbound state that I described earlier an example of sublation, whereby depleted resources reinterpret themselves as power, and rise up to declare *the right of frost*— the right to be seized by frost and to declare frost a higher form of ardor? Hegel: "Starting from the Subject as though this were a permanent ground, it finds that, since the Predicate is really the Substance, the Subject has passed over into the Predicate, and by this very fact, has been sublated; and, since in this way what seems to be the Predicate has become the whole and the independent mass, thinking cannot roam at will, but is impeded by this weight." I can picture the Subject passing over into the Predicate. I imagine the Subject as a night wanderer, like the heroine of Charlotte Brontë's *Villette*, in a somnambulistic trance, prowling through a fictionalized Brussels. Once, I behaved like Hegel's Subject. On a camping trip in sixth grade, I sleepwalked into an adjacent campsite, and entered the sleeping bag of a boy I didn't know; I told him, "Get out of my sleeping bag!" With these magic words of exile, I woke up.

9.

Recently I made a painting based on the penis of my friend Brian, an art critic. My technique was to drag a pencil through a layer of drying but still wet gesso, as if the pencil were a carving tool, and the gesso were marble. On Twitter, Brian circulated a photograph of my painting, which he called, in his tweet, "a painting of my d." D was lowercase. My d. Lowercase "d" sounds less sexual than the word *dick*. Lowercase "d" de-monumentalizes the dick. After the "d," Brian put no period.

A sentence without a comma is often a glorious thing. Washington Irving begins the final paragraph of his essay "The Art of Bookmaking" with such a sentence, comma-less and therefore at liberty to please any visitor, however paranoid: "The librarian now stepped up to me and demanded whether I had a card of admission." Though I have no card of admission to the palace of art, I drag my pencil through drying gesso; I like the resistance offered by gesso, en route to marmorealization.

10.

Jane Jacobs, in her classic *The Death and Life of Great American Cities*, speaks in favor not of the marmoreal but of the various. Variety, she argues, makes for safety. In a list, its noun phrases separated by commas, Jacobs lays out the floor plan of throng consciousness, of *heimlich*

conviviality: "The floor of the building in which this book is being written is occupied also by a health club with a gym, a firm of ecclesiastical decorators, an insurgent Democratic party reform club, a Liberal party political club, a music society, an accordionists' association, a retired importer who sells maté by mail, a man who sells paper and who also takes care of shipping the maté, a dental laboratory, a studio for watercolor lessons, and a maker of costume jewelry." I am most interested in the maté, a caffeinated beverage I've never tasted; call it the unheard melody of Jacobs's building. The maté is where I listen most keenly, because I can't hear maté, can't taste it, can't remember it, can't picture it. "Maté" is the most conspicuously foreign element in Jacobs's sentence. Maté, to which Jacobs gives the unrequired benefit of an acute accent, enlivens any community, linguistic or social, in which it dwells. To become the maté in someone else's sentence—to become the substance that circulates through an unidentified building—to become, as it were, the *kif* of a social theorist's consciousness: is this my newest aspiration? Or am I content to be a painter of "d," a writer who drags his pencil through gesso? Gesso's fumes, the internet assures me, aren't poisonous, though they assault my nostrils with a sting I associate with the ammonia that porn emporia use to clean spunk off their floors.

11.

Did Kandinsky ever notice the color of his spunk? From *Concerning the Spiritual in Art*: "An attempt to make yellow colder produces a green tint and checks both the horizontal and excentric movement. The color becomes sickly and unreal. The blue by its contrary movement acts as a brake on the yellow, and is hindered in its own movement, till the two together become stationary, and the result is green." Do you believe him? Thinkers who make absolute statements—whether about yellow, green, comma, or period—often allow a pejorative, diagnostic tone to infect their sentences. I don't trust a person who calls a color sickly. And yet I think Kandinsky was trying to describe an experience he'd frequently had—an experience of seeing colors wiggle, rush, combine, slow down. He responded to this experience by generalizing, by trying to lay down laws. Laws, however, don't help new experiences come into being; I'd rather that Kandinsky had told me exactly where he was standing or sitting when he most recently saw blue act as a brake on yellow.

12.

"The best way to defend oneself against the invasion of burdensome memories is to impede their entry, to extend a *cordon sanitaire*." Primo Levi originally wrote that sentence in Italian. Perhaps he included the French phrase *cordon sanitaire*, or perhaps his English translator,

Raymond Rosenthal, gave it to him. *Cordon sanitaire* is a phrase I often use. It establishes distance from a subject, while endowing the avoided topic with an atmosphere of Gallic refinement. Freud was familiar with such moves. He fell into French whenever possible, to avoid besmirchment. Those who theorize besmirchment aren't necessarily in love with the experience of having dirty hands. We use language to keep away from the subjects that first drove us into language.

13.

Time to opt for plainness. Pack the information sardine-tight. Kipper the truth, in the briny manner of Friederike Mayröcker, who condenses language even while liberating it to flow. First thing to go are capital letters. In her book *with each clouded peak*, translated from the German by Rosmarie Waldrop and Harriett Watts, the sentences, if they are sentences, come mostly without capitals. Kipper the truth by uncapitalizing. In a chapter called "indications," Mayröcker begins, "the power plant glittering, he said, quite contrary to." Quite contrary to what? In the vicinity of a glittering power plant there isn't time to ask stupid questions; you should be worried about radioactive fallout, not punctuation or syntax. The period, arriving perplexingly after "quite contrary to," and cutting off the noun that would be the preposition's destined object, underscores anxiety while calming it. When a

sentence prematurely ends, an emergency government takes over. Quite contrary to the usual regime of glitter, the false consciousness offered by shininess, I received from Mayröcker's interrupted sentence the extreme unction of Full Stop.

14.

The nectar of interrupted consciousness I sip through translated sentences. Nietzsche, mediated by his English translator Walter Kaufmann, diagnoses an incapacity that permits a contrary flourishing, as if *against* the glitter of workaday power plants spewing their filth along the city's riverbank. Nietzsche, *The Gay Science*: "We *are* something different from scholars, although it is unavoidable for us to be also, among other things, scholarly. We have different needs, grow differently, and also have a different digestion: we need more, we also need less." May I, too, declare a different digestion? I need immense liberty, though after stealing a wide pasture I experience it as a terrible confinement. In the midst of a digressive journeying I elected, my writing body feels pierced—punctuated?—on all sides. When, in language, I seem most free, I still feel chained—prodded and pinched by a demand that every sensation and intuition must pass through a linguistic sieve. Functioning within language—even *free* functioning, a writing that seems lubriciously at ease—demands a *cordon sanitaire*, a tight

cincture. The cincture is the sentence, whose corridors are barbed. And if I could escape the sentence, would I want another home? Would I be happier in a land of permanent interruption, *quite contrary to?*

15.

"The Jew delivered the cocaine the same day, and promptly vanished." So says George Orwell, in *Down and Out in Paris and London.* Inside the front cover of this old paperback, I found the flattened carcass of a dead insect. I'll call it a gnat, though I'd like to dignify the interloper with the German word that Kafka used to describe his sad Gregor—*Ungeziefer*, which descends from a Middle High German word meaning "unclean beast not suited for sacrifice." Orwell littered his sentence with a blessedly unnecessary comma: "The Jew delivered the cocaine the same day, and promptly vanished." The comma allows us to feel an interlude of time elapse—the interval of delivery—before the final vanishing occurs. The comma is the cocaine.

16.

I am not puzzled by aura. I find it everywhere. The students of literary critic Marjorie Perloff, however, apparently stumble in the unauratic dark. In her memoir, *The Vienna Paradox,* she admits, "I have frequently taught Walter Benjamin's essays and find that students today

are puzzled by the concept of *aura.*" That sentence is graced by the absence of a comma. Sometimes life can bring you pleasure without commas, without undue self-castigation. You don't need commas to perceive aura. You need simply to remove obstructions from your vision. A comma is not necessarily an obstruction. My true subject, anyway, isn't punctuation; punctuation gives me an apparatus with which to claim nearness to genuine surprise. Punctuation, today, allows me occasional—fleeting—proximity to suddenness. Suddenness is how I recognize aura: its quick arrival. And so I am always trying to listen closely to the timings of arrivals and exits. When information leaves and invades a sentence—when a sentence submits to interruptions or forbids them and proceeds without pause—for these durational issues, which impinge on aura and elucidate it, we thank and blame punctuation.

<div align="center">17.</div>

"*si tu t'imagines / si tu t'imagines / fillette fillette / si tu t'imagines . . .*" Juliette Greco sang this song, composed in Paris by Hungarian-Jewish emigré Joseph Kosma, to a poem by Raymond Queneau, who put no punctuation between repetitions of the phrase "*si tu t'imagines.*" Kosma sculpted the melody to articulate the gaps that Queneau didn't bother to write. Greco's timbre befriends the void the words ward off—the abyss of squandered time. We,

listening, are the *"fillette"*—one translator renders the
phrase in English as "baby doll"—who needs to learn
the lesson that bodies don't last. As a child I borrowed
from my mother's shelf a paperback copy of Tennessee
Williams's *Baby Doll*, and never returned it. I decreed—
without saying so—that I was the rightful, destined
owner of *Baby Doll*. If each book has a *fillette* to whom it
addresses its sultry *carpe diem*, then I was the *fillette-lecteur*,
hypocritical and slim, of *Baby Doll*, a vehicle that epito-
mized Williams's drink-soaked path to ruin.

18.

My body is a problem for me. If I were a woman, would
my body be *more* of a problem? Adrienne Rich thinks so,
and I usually agree with her pronouncements and lita-
nies because they are voiced lyrically, gemmed with spe-
cifics, and paced deliberately, with abundant commas,
like wisteria vines, or like a clematis learning to open for
the first time. In *Of Woman Born*, Rich observes: "I know
no woman—virgin, mother, lesbian, married, celibate—
whether she earns her keep as a housewife, a cocktail
waitress, or a scanner of brain waves—for whom her
body is not a fundamental problem: its clouded mean-
ing, its fertility, its desire, its so-called frigidity, its bloody
speech, its silences, its changes and mutilations, its rapes
and ripenings." We receive from Rich a cornucopia of
stoppages and pauses; her sentence's clairvoyant candor,

like a Cassandra who'd graduated to the pulpit, extends
its Solomonic cadences toward me, as if I were the *fillette*
accepting her visionary call. To surround my description
of Rich's sentence with ironic trappings should not ob-
scure my "bottom nature" admiration—nay, worship—
for its tempo and its truthfulness.

<div align="center">19.</div>

The phrase "bottom nature" is Gertrude Stein's; I use
it all the time. I like "bottom nature" because it lightly
touches the fundament without dirtying itself by actu-
ally mentioning buttocks. The phrase "bottom nature"
has a Hegelian vastness. "Bottom nature" implies a phil-
osophic eye looking deep into history's cycles and ex-
ercising a knack for gyres. A sentence from Stein's *The
Making of Americans*: "It happens very often that a man
has it in him, that a man does something, that he does it
very often, that he does many things, when he is a young
one and an older one and an old one." By man, maybe
Stein means woman. Stein didn't like commas but she
used several here. It happens very often that Stein wants
to help the reader perceive the pause, which captures
indrawn breath, rising and falling pitch, and the pa-
tience of a speaking voice forgiving its puerile Ameri-
can readers for their inability to hear the words actually
being spoken to them. Stein's "man," through patient
proclamation, gives the reader a model for how to dwell

solidly—thinking through the bottom—within the sentence whose landlocked cubits are our temporary portion.

20.

Stein's Cantabrigian predecessor in the fine art of measurement, Henry David Thoreau, also believed in thinking through the bottom; bottom-nature thinking, when it takes root in writing, can enjoy the benefits of self-interruption as well as stopless unfurling. Thoreau preaches the virtue of "short impulses," or of long journeys broken into brief intervals. From *Walden*: "When the surface is considerably agitated there are no skaters nor water-bugs on it, but apparently, in calm days, they leave their havens and adventurously glide forth from the shore by short impulses till they completely cover it." Thoreau praises the water-bugs and the skaters for their quick, short surges of movement—sprints based in a bottom-nature "impulse" that may not have its source in a belief or an intention. An impulse need not be the consequence of a wish or a decision. Thoreau's sentences, like Emerson's, are masterfully terminal. When they end, they truly end. They don't wait around for the next one to start. Frequent and solid division of thought into dosed increments—the tempo of the dosage announcing itself through punctuation—reflects Thoreau's preference for impulses that don't distort themselves through undue prolongation.

21.

Not ending has its joys. Not ending, but dramatically pointing toward onwardness without actually venturing there . . . Ellipses—dot dot dot—open onto death's patio. Like a tease, Giuseppe Ungaretti, in the tiny poem "Statue" (translated by Andrew Frisardi), fingers the abyss with the three-dot salute: "Petrified youth, / O statue, O statue of the human abyss . . ." Ungaretti's sentence isn't going anywhere. It takes pride in verbless petrifaction. Identifying with a kouros is a glamorous— idealized—way of being miserable. Literature specializes in stopping the moment, killing it, staging its blight and its bloom. The woman who long ago gave me a volume of Ungaretti—untranslated—vanished from my life, and I vanished from hers; I think she resented me for being apparently well-adjusted. She looked like Jeanne Moreau; for a few days, in her presence, I pretended to be straight. After visiting her family for Christmas, she came back and told me this story: her father—a drunk?— had slapped her face, though she was already an adult. Traumatized, she vowed never again to visit him. I have a petrified relation to the tale I'm now repeating: my voice's emotional miserliness and linguistic meagerness reflect a stone's inability to feel empathy with other stones.

22.

Because we are, at heart, a stone, or understand that our short impulses have unyielding stoniness as their career's end, we try to fill our days with as many impediments as possible. "Very difficult very difficult," Vincent van Gogh repeated, without a comma, in a letter to his brother Theo. Vincent was in the last year of his life; fresh from the asylum, he busied himself with forecasts. "For there are beautiful autumn effects to do . . . [T]he olive trees are very characteristic, and I am struggling to capture them. They are silver, sometimes more blue, sometimes greenish, bronzed, whitening on ground that is yellow, pink, purplish or orangeish to dull red ochre. But very difficult very difficult." ("*Mais fort difficile fort difficile.*") Is he bragging about the difficulty? Worried about it? Difficult for him, because of his addiction to infelicity, or difficult for anyone, even the most conventionally skilled? Did he understand that this difficulty would become, in a decade or two, modernity's braggart signature? And are we wrong, or hasty, or tendentious, to point out an affinity between difficulty and a sentence's tempo, its repetitions and pauseless staggering? It's ten dentious, perhaps, to cling to any system, including the protocols I employ to inch forward my language, as if I feared that language's deeper wish (its bottom nature) were to cease, and as if I were (as writer) always in the

position of goosing language to keep it going. Dreams, in Freud's view, might have been a system to keep wishes going; dream-codes (condensation, displacement, and other forms of symbolization) served not to express wishes but to produce them, and then to pretend that the wishes came first.

23.

"The odor of rot had become so general that he no longer smelled it," writes Richard Wright in his story "The Man Who Lived Underground." I don't live underground; nor, precisely, did Wright, though he lived within a system of racism and actual bodily peril that gave him license to use the metaphor. How I generalize, and why I generalize, and if I have the right to generalize, are the questions preoccupying me now. Rot has become general; I don't want to be complicit—or to admit my complicity—with its spread. (If, in this essay, I have an unstated, impossible subject, it might be ecocide and its embeddedness within linguistic inattentiveness— call it the rot of the world's speaking mouth or the world's listening ear.) If we carelessly lump concepts together, or if we think too rigidly within a system of concepts, we may succumb to false certainty, and to tones of voice that can speciously argue for anything, and that can malignly side with a cultural system forbidding slow discernment.

24.

Greek composer Iannis Xenakis, who lived underground, at least for a time (he escaped from a prison camp and lived secretly in an apartment), and who lost his left eye to shrapnel in 1945, had a complex relation to systems. Was his relation amative or suspicious? (Although he is celebrated for engendering a math-oriented compositional philosophy known as *musique stochastique*, I imagine that he regarded systems with a mixture of fear and love.) In an essay entitled "The Crisis of Serial Music," he writes: "Linear polyphony destroys itself by its very complexity; what one hears is in reality nothing but a mass of notes in various registers." I hear the semicolon dividing his sentence in two. The text's original is in French, though published in a German journal; Xenakis was born in Romania to Greek parents. Did he experience this abundance of languages as a destructive polyphony? Please note that *stochastic* comes from a Greek word meaning "aim."

25.

My aim? I fear that aiming is violent. To *tend*—stochastic music relies on probability, not on ironclad will—is gentler than to *aim*. Poets rarely aim; essayists sometimes aim. (Maybe Homer aimed. Homer wrote the book about shrapnel.) John Yau, an art critic as well as poet, composed a poem ("830 Fireplace Road") that consists of variations on a sentence by Jackson Pollock,

who pioneered a metaphoric relation between urination and painting, and whose works seem governed by wish rather than intention, and by tendency rather than decision. "When I am *in* my painting, I'm not aware of what I'm doing": that's Pollock's line. One variation, coined by Yau, is "When I am my painting, I'm not aware of what I am." "I" is an aim; I don't need to aim my "I," which comes equipped with memories, patterns, and habits. To mute the possible violence of an aimed "I," we punctuate our impulses, lest our impulses take revenge by punctuating us. Pollock didn't aim at the tree his car hit.

26.

We have reached the end of our journey. On October 17, 1970, Unica Zürn, a Surrealist artist and writer, killed herself by jumping off the sixth-floor balcony of photographer Hans Bellmer's apartment, in Paris. Her novel *Dark Spring* (translated by Caroline Rupprecht), written in 1967, ends with the suicide of a twelve-year-old girl. "'It's over,' she says quietly, and feels dead already, even before her feet leave the windowsill. She falls on her head and breaks her neck. Strangely contorted, her small body lies in the grass. The first one to find her is the dog. He sticks his head between her legs and begins licking her." These last two sentences have no commas. Speediness and matter-of-factness and pauselessness underscore their obscenity, their lack of affect. Who sees

the dog lick the dead girl? The writer sees. Unica Zürn sees, and writes it down, and wants us to see it, too. *Dark Spring* was written originally in German. "He sticks his head between her legs and begins licking her" might have commas in German. "The first one to find her is the dog" might have commas in German. I don't know why it matters whether or not these two sentences have commas; I came to the scene of this essay, the one I'm now ending, to get assistance in figuring out why it matters whether or not there were commas in the German original of the death scene. It would be tendentious to point out that Paul Celan killed himself, also in Paris, in April 1970, almost exactly six months before Unica Zürn leapt to her death. It would be misleading, it would be melodramatic, to say that six months punctuated the two suicides.

(2014)

ON FUTILITY, HOLES, AND HERVÉ GUIBERT

In a somber essay I wrote in 1989 and haven't reread in twenty-five years, a piece whose heavyhearted title was "Speaking in the Shadow of AIDS," I concluded: "The motive behind this brief inquiry into AIDS and language has been an attempt, perhaps immodest, to mold words into something stainless. AIDS has made me watch my speech, as if my words were a second, more easily monitored body, less liable than the first to the whimsy of a virus. . . . Bodies have always wanted only one thing, to be aimless: or so I say, knowing that *bodies*, and *always*, and *aimless*, are among the most seductive, and the most outdated, of the several rhetorics I must soon discard." I still haven't discarded those rhetorics. When I wrote these words, I hadn't yet heard of Hervé Guibert, the French novelist, memoirist, critic, and photographer who would die of AIDS in 1991, at the age of thirty-six. I regret my ignorance. Now, after reading his posthumously published journals, translated into English by Nathanaël

and published by Nightboat Books, Guibert's life-work looms before me not merely as what Keats called (describing the Elgin Marbles) the "shadow of a magnitude" but as the magnitude itself, sans shadow.

I might as well mention some impediments. I can't write about Guibert without mentioning his beautiful face: his literary greatness is tied, Laocoön-style, to his attractiveness. I can't write about Guibert without noting the historical coincidence that he's dead and I'm not: he was born only three years before me. And I can't objectively evaluate the work of a writer I take personally and envy, though I can't entirely wish to trade places with a man—however much he qualifies as an idealizable hyacinth—who died so young.

Must I admit impediments—or, as Francis Ponge put it, "open a notebook"—to write a simple essay? No essay is ever simple. Listen to Ponge: "I never choose the easiest subjects; that's why I choose the mimosa. And since it's a very difficult subject, I must open a notebook."

Time to plunge into the explanatory task. End of notebook.

✦

Genet's work might have taught the young Guibert to connect violence and desire, or maybe the wunderkind figured it out for himself. With or without tutelage,

he quickly discovered how to worship a beautiful body while also wishing to despoil it. Punctures and holes gave him literary energy; gold-panner, he remapped the male body (not famous for its holes) as a gap-ridden and therefore ontologically profound locale. To acknowledge plural orifices is to acquire—if not agency—then majesty, complexity, cavernousness, tingle, introspection, enigma. And therefore Guibert (with Michel Foucault, Guy Hocquenghem, Tony Duvert, Dennis Cooper, Pierre Guyotat) sought to write hole-conscious fiction and theory, a prose eager for rifts in maleness wherever those rifts could be found.

Guibert's journals, *The Mausoleum of Lovers*, form a vast arena of such holes—an operating theater, a humming phalanstery, filled, yes, with jetting, penetration, jacking off, and with anuses that are distinctly *male*—but also writing these hot zones *in time* and not as monolithic forces, writing these pricks and surges of desire as mistakes, falls from grace, and narrative absences. Where story falls apart, Guibert's journal begins; where an erection happens, writing becomes futile but also gains the energy to articulate its own futility. Erection—occasion for journal-writing—announces not a triumphant arrival but an aporia, a goof, a misprision, a chance to stumble into impossible, irresolute speech.

Guibert became famous in France in 1990 when he published a roman à clef about Foucault's death, *To the*

Friend Who Did Not Save My Life. (This book's notoriety seemed to center on Foucault's scandal, not on Guibert's artistry, as if the younger novelist needed the sage philosopher's authorization to register on the media's map.) Guibert published many short, svelte books that straddle the line between memoir and novel (including *My Parents, Blindsight,* and *The Gangsters*), but every project took root in his notebooks, a hive of errant record-keeping, with family resemblances to such untidy masterpieces as Gide's and Thoreau's journals, Valéry's *Cahiers,* and Lichtenberg's *Waste Books.* Guibert's published work, even at its most elegant and stylized, retains the casual intimacy of his journals. He valued the diary, as genre, not because it had the potential to be supremely honed but because it wrote time and wrote body accurately, wrote body as it actually occurred, nonmonumentally, *in* time. Plotless, accidental, the journals exceed authorial jurisdiction; they do not reduce to a clear, univocal intention. Gestated originally for private purposes, they are not wholly aimed toward reader, publication, or closure.

An unbridled, impatiently probing eroticism gives heat to Guibert's clock-haunted *Mausoleum.* What he eventually suffered, and what killed him, took place in time, and had a relation to his sexuality. Let me put it more "safely": the discourses engulfing AIDS were precisely the languages of wound—of contamination, filth, and mistake—that he'd already been plumbing and

relishing, vocabularies he obtained from Genet, from the données of the French language, from Barthes and Foucault, from looking in the mirror, from his camera, from pornography, from his crazy great-aunts, from his mother who wiped his bottom until he was thirteen years old, from his father who punched him in the jaw. The rhetorics of wound and of abjection that nourished him and that formed the nucleus of his sexual *imaginaire* were then drowned out and ventriloquized by the mytholo - gies of AIDS; Guibert already spoke the lingo of Wilde's Dorian Gray before AIDS rewrote Wilde and took him on as its untimely echo. Guibert investigated sexuality; a private eye, working for no government, he sleuthed with a rare ferocity and candor. Premature death cut off the investigation.

Enfant terrible, Guibert in his journal took on the project of writing sexuality in time—the project of writing sexuality *as* time—at a moment in history when the time-bound nature of sexuality underwent a Grand Guignol twist, a contortion that forced Guibert to play sacrificed subject as well as documentarian and theorizer. Although the journals rarely mention AIDS by name, we're stuck, reading Guibert, within a sexual reckoning in which AIDS serves as dreaded, detested curtain. He attempts to conquer time by anatomizing orgasm's prequels and sequels: "Then I remember how I came, watching him jerk off, naked, from afar, while crying (but all of this

is unmentionable)." Eroticism's contingency thrives—or finds brief staging—within parentheses.

Sexual, wounded, hole-ridden, philosophical, the pages of his journals drip with ontology—so much *Dasein* he can't stuff his sentences back into their undies. Guibert's clauses, groomed and ungroomed, bring jacking off or being jacked off into propinquity with the Crucifixion and other emblems of sacred, unbearable duration: "I am licking icons (the thought arrived while coming alone last night)." Dead art gives him a boner: "A strange thing happens, as soon as I enter a museum, infallibly, I become hard. . . . I harden among all those dead faces." Desire instigates ossification and reification: the "I" stiffens. No way to photograph without understanding astonishment; no way to write (or publish) a sentence without surrendering to erotic marmorealization, an unmelting, Madame Tussaud-style knowledge that aches.

✦

Filth is Guibert's passport to infinity. Filth, as literary terrain, belongs to Sade, but Guibert reroutes S/M through the pastoral landscape of religious interiority, as if ghosted by hungry Simone Weil, or by Wilde's scarified, Christological denouement. (To skeptics, such spirituality might seem papier-mâché, but I'm a believer.) Guibert sees a cute young man at a party and "instead of

imagining his sex or his torso or the taste of his tongue, in spite of myself it's his excrement I see, inside his intestines." In Guibert's universe, shit may be scary, but it possesses the indisputable, definition-proof aura of Dickinson's "Circumference." He writes, "There were traces of shit, from after sodomy, visible on the top of the nonetheless dark sheet on which I was sitting, while I was attempting to seduce the young man sitting next to me on the armchair, I realized the young man might catch sight of those traces of shit." No problem, if Hervé's gentleman caller glimpses sodomitic stigmata, a soiled badge of honor crucial to the journal's sweet-tempered transvaluations.

To have a cock is to wish to destroy the cock; "having" a cock, not a secure position, causes consciousness to teeter, tumble, and misplace itself. "I would like to chisel bits of grease out of my skin, disembowel myself, open my stomach and void myself." Sex unwrites a body's wish to remain composed: "On my way home, I want to scald my cock." Another characteristic sentiment: "if I fuck him, if I decide to fuck him, it's first to annihilate him." No simple sadism here, no simple equation of fucking and killing, of penetrating and violating—instead, the wish to fuck or to be fucked, like the experience of "having" a cock or of only semi-having a "cock," is a sensation (or a memory cathedral) of being voided, chiseled, scalded, disemboweled. Is this consciousness a queer privilege? Is

it shamanistic? Is it in fact not trans or queer or any-thing of the sort, but simply poetic? "I am forced to con-cede that I adore wounds," writes Guibert (author of the screenplay for Patrice Chéreau's film *L'Homme blessé*), af-ter HIV has already made its presence felt in the world.

Though Guibert, like Gide, is no stranger to melo-drama, nor to the tendrils of self-pity and self-stylization that drape the thespian face, *The Mausoleum of Lovers* doesn't sugarcoat desire: "Dream of the joy obtained by the spectacle of a very small child raping a man," writes Guibert, who reflects occasionally, and without an abun-dance of veils, about a sexualized love for children. "In the morning I jerk off to discharge some of my tension, but it is also like a prayer for a child's cock to come as soon as possible into my mouth." This prayer comes from a man who as an adolescent put his own hard cock over a glossy picture of an actor (Hiram Keller) from Fellini's *Satyricon*; like Genet's narrator at the conclusion of *Our Lady of the Flowers* (where a prick dovetails with its pen-cilled outline), Guibert wanted to shove his body directly into words and images, without polite filter. He sought a prose as direct, voracious, and soul-capturing as pho-tography. Visually oriented, process-centered, he hoped at the end of his short life to write a "treatise on draw-ing." Journal-keeping, as he practiced it, shared draw-ing's fluent, linear, accident-prone, time-scarred nature: "(I feel as though I'm writing a book when the writing

is something like drawing on the pages.)" You prove a book's veracity, Guibert suggests, not by its content but by the sensations you experience while writing it. The writer, not the reader, knows best.

Fathers are depressing but necessary and sometimes sexually alluring; fathers, and father-substitutes, and ghost-fathers, appear often in Guibert's journal, as do mothers, who are also depressing but necessary and sometimes sexually alluring. "T. licks my ass while I'm talking to my father on the telephone" is one way to deal with fathers and their necessity. Another way to deal with fathers is to record nuggets like the following: "My father ate my snot." An innovative approach to nuclear-family ecology! His mother, who tried to have a miscarriage when she was pregnant with Hervé, later confesses to him, "I would like so much to be lying on your bed, motionless, without saying a word, so as not to bother you, while you are writing in the next room." His mother and his father dwell inside Hervé's writing, even when he tries to expectorate or exile them from it. Hervé admits to his mother, "If I had a child . . . I would rape him, I would kill him"; and he dreams of getting fucked by his father, who, in the dream, says, "He who has his ass stuffed is damned."

A born diarist, Guibert regarded the genre of "novel" with a fatigued, valedictory suspicion: "it is perhaps preferable to circle around the idea of the novel, to dream

it, like in Gide's *Marshlands*, and to botch it, rather than
succeed, since the successful novel is perhaps a very ba-
nal form of writing." He wants writing to be a form of
physical adventure—a leap, a plunge, a way to befriend
the abyss: "I would like one day to throw myself into a
narrative that would be but an event of writing, without
a story, and without boredom, a true adventure. . . . The
other day I wrote that it was necessary to surrender to
pure events of writing (just as the most pure photos are
pure events of light)." What is a pure event of writing?
Certain French thinkers called it "writing the body," a
phrase that doesn't get sung a lot these days, though I
hope that Guibert's journal will bring this philosophi-
cally inclined subset of body-smeared literature back into
prominence. What else is there to write but the body?
"Pains in my left eye where it seemed I let a bit of semen
penetrate by rubbing my eyes after having jerked off . . ."
As in Monique Wittig's pronoun-slashed *The Lesbian
Body*, every organ, within Guibert's literary body, intra-
murally huddles with its mates; his journal invents a body
where "semen" and "left eye" belong to each other, even if
their spunky wedlock causes distress.

Maybe no passage in the journals is more heart-
breaking and operatic (time-shattering, arrested, poly-
vocal, Orphean in its compulsion to move forward while
looking backward) than Guibert's description of sex's
proximity to death: "T. and I had started fucking again,

but he had to go to his appointment at the ophthalmol-
ogist's. He returns saying it isn't a conjunctivitis, but a
white veil over the eye, he says that it must be a mani-
festation of AIDS, that he's going to go blind, I would
like to dissolve on the spot; we try to continue to fuck
anyway, it's dreadfully sad, I have the impression that we
are adrift between our lives and our deaths, planted deep
in my ass, he makes me come looking me in the eyes, it's
too sublime a look, too rending, both eternal and threat-
ened by eternity, I block the sob in my throat passing it
off as a sigh of relaxation." This brutally fluid interlude
is remarkable for its punctuation and its lack of punctu-
ation, its ambivalent commas, its wish to thread together
life and death, fucking and sightlessness, sobbing and re-
laxing, writing and enduring, transcription and epitaph,
documentary and poetry.

Transparency is Guibert's method; transparency—his
relatively unadorned language, which combs its hair but
doesn't disguise the disorders of the underlying scalp—
perhaps explains why he has not been more frequently
translated into English, as if a literature that purported
to be see-through couldn't also claim opacity. In 1991,
Atheneum published *To the Friend Who Did Not Save My
Life*; in 1996, Sun and Moon released Guibert's treatise
on photography, *Ghost Image*, reprinted in 2014 by the
University of Chicago Press. (In *Ghost Image*, whose ap-
proach to analysis is gossamer *récit*, Guibert recounted a

memorable faux pas. He wrote to Barthes and asked to photograph him and his mother, but received no answer. When Hervé telephoned to ask "if he had in fact received my letter," Roland said "Haven't you heard? *Maman* died ten days ago . . .")

Why has no thoughtful publisher translated and published all of Guibert's works, in trim editions, each cover graced with a photo of the seraphic young Hervé, succulent as Jean-Hippolyte Flandrin's *Nude Young Man Sitting by the Sea* or Anne-Louis Girodet de Roussy-Trioson's *The Sleep of Endymion?* Literary culture in the U.S.—even at its most adventurous—hasn't got Guibert's message, perhaps because his diaristic works emphasize sex and death and an unclassifiably perverted subjectivity, alternately raging and depressed, and perhaps because he clothes his seamy burden in a language unadorned, pellucid, provisional, and loosely constructed. To recirculate Guibert would serve to honor and resuscitate a project that Robert Mapplethorpe and David Wojnarowicz and Jack Smith and Jimmy DeSana and Mark Morrisroe and Félix González-Torres and Paul Thek and Marlon Riggs (and I am culpable for leaving out a thousand other names) also pursued, a cross-personal project that sometimes achieved commercial or media visibility but that mostly fell through the cracks because its practitioners died too soon or left their materials in forms and genres either too perishable or too messy or too bizarre for

easy repackaging. To get Guibert's full message, which isn't light-years apart from Susan Sontag's and Frank O'Hara's New York–based credos (pay attention, live as variously as possible) but that chose for its transmission not the lyric or the essay but the autofiction, the fragmentary self-articulation, casual as a snapshot, would involve questioning straitened notions of what constitutes a polished piece of writing, or a life's work, or an autobiography, or a sexuality, or a successful venture and learning, instead, to appreciate the cadences of catastrophe, of self-excavating improvisation, and of unknowingness. Futility and botched execution are the immortal matter of Guibert's method. Futility and botched execution—combined, in Guibert's work, with finesse, concision, and a heavy dose of negative capability, which includes a curiosity about the worst things that can befall a body—are undying aesthetic and spiritual values, worth cherishing in any literature we dare to call our own.

(I began this essay in Baton Rouge. I revised it in New York. I finished it in Miami.)

(2014)

RIDING THE ESCALATOR
WITH EVE

To tend her butt, to tender buttons: critic Kathryn Kent taught me that double entendre, at Eve Kosofsky Sedgwick's house in Durham, in 1995. I tend now, even in ordinary speech, to sport Eve's Jamesian syntactical complications *feelingly*; to insert the adverb where it doesn't belong; to implement anal innuendo, long my calling card. Last night I dreamt that Gertrude Stein appeared "live" in a production of *Four Saints in Three Acts*; a trained belter, she sang brightly, with comic exactitude. I want to tell Eve my dream—to stimulate her by saying, "I realized that you *were* Gertrude Stein—a playful, obscene originator." But instead, because Eve is dead, I can only repeat to you this sentence—a favorite—from *Tendencies*: "The most self-evident things, as always, are taken—as if unanswerably—to be the shaming risibility of any form of oblique or obscure expression; and the flat inadmissibility of openly queer articulation." To be queer and to be unclear, to know that the truest

sentence you can write might be the most roundabout, the most misleading, the most addicted to avoidance, the most masturbatory—which simply, didn't Eve teach us, means the most spacious, the most ready to offer entrance and egress to readers hungering for solitary friction? In December 1991, to escape the MLA convention, Eve and I went shopping in San Francisco. We rode the escalator, up and down, in a Union Square department store. Then we ate Buddha Buns at a restaurant now defunct. I remember Eve saying "Buddha Buns," singling them out; I was one stimulated recipient of her word-savoring.

✦

To states of fatigue as well as to states of rapid energy she had the knowledge of how to attach herself; attachment, adhesion (including attachment to her audience, interlocutors, collaborators, students) were her gifts and signatures. She wrote: "I think that for many of us in childhood the ability to attach intently to a few cultural objects, objects of high or popular culture or both, objects whose meanings seemed mysterious, excessive, or oblique in relation to the codes most readily available to us, became a prime resource for survival." Attach willy-nilly to the most obscure, the most mysterious, that which can't be pinned down, claimed,

husbanded. Attach to sentences, too, more for their at-
mosphere than for their overt meaning; attach to time
itself, including the temporal schism separating 1993,
when *Tendencies* was published, and this dismal yet un-
avoidably precious "now" of 2018. Attach to the inter-
val, the twenty-five years. Hug the interval. Let yourself
be cinctured by that lapse of time you can't understand
or forgive. You can't—I can't—forgive 1993 for not
being here now with us again and perpetually; I can't
forgive a world that doesn't attend to 1993's originary,
clause-spangled beatitude. Because she felt "a visceral
near-identification with the writing I cared for," *Ten-
dencies* authorizes me, now, to near-identify viscerally
with her manifesto-sentences that call for a lavishly
invested critical-poetic style. Unanswered questions
throng me. I want to ask Eve what happened to the
ritually spanked woman in her poem "Lost Letter"; I
want to ask Eve about being in bed with Michael Lynch;
I want to ask for more details about the ass of Mon-
sieur O., the high school French teacher seen inadmis-
sibly from behind. I can't forgive 2018 for not taking
in gaily a style of critical gaming as amply "showy" as
Eve's. *Don't polarize*, I tell myself, following Eve's exam-
ple; don't make a binary of 1993 and 2018 and then act
brutalized by a paradigm you've coined. We call on the
books we've loved—the books from our past—to help us
measure the present. As everyone seemed to be reading

Hannah Arendt's *The Origins of Totalitarianism* after the recent catastrophe, so please everyone start reading *Tendencies* to absorb a revelation as oddly simple as the fact "that most people in the world, whatever their gender or sexuality, don't form or maintain libidinal cathexes toward most other people in the world." Isn't the inestimable preciousness of the singular—the individuated, the endangered, the specific—her message to us? Singularity of an adjective—call it *adjectivity*; singularity of the odd word *ruly* in her phrase "the ruly ordinariness of this sight." Singularity of a style, a thought-pattern hammered and glass-blown into sentences that make as many demands—textured, flaming, often *nonspecific* demands—as possible. Her nonspecificity sometimes tied me up, prompted me to impugn my own hunger for literality. Perhaps it was the half-discernible presence of the specific within the foggy nonspecific that constituted the formidable, mind-teasing allure of her critical movements. She invites us to make kink a home *and* a homing device to help us disorient any location whose buttons are too neatly fastened. In her prose's presence I can only ever be indirect.

✦

Does the academic world any longer have the resources to reward, justify, nurture, and sustain such rhetorical

performances as Eve's, such stressed enactments of crit-
ical art? Her performances willfully seduced an audi-
ence schooled in deconstruction (and its sequelae) but
eager to see those strategies split open by new erotic af-
firmations and demands. The presence of "Eve" again
here wakes in me an impulse to wed verbal exhibition-
ism with erotic magnanimity—a desire to draw no dis-
tinctions between verbal display (engorged rhetoric)
and a seductiveness rarely physical but therefore (think
foreplay) more tensile with the anticipation of corpo-
real thrill, as if chiasmus were itself a caress. She prac-
ticed, like grand opera at its height, a luxury economy:
call *Tendencies* the *Don Carlo* of lit crit, complete with
auto-da-fé.

✦

Eve didn't need the auspices of literary criticism for her
brilliance, but she thrived within academia's thorned
embrace. Her work wasn't produced for professional
respectability but was formed by the nearby shadow of
those offices—as if Paul de Man and Edith Massey were
her project's joint choir-directors. I've never had an ade-
quate way of describing the nature of Eve's brilliance, her
capacity to inflame with a cascade of complications, each
etched difference opening in our speculation-tickled
bodies a new possibility for treating stigma (debility,

clumsiness, flaw) as the origin of a new, impossible erotics. Or maybe it isn't new. Maybe I say "new" in order to persuade you to adopt this unspecifiable erotics as your own fond possession—an anti-systematic, equilibrium-forging toy, or tool, or entreaty, that doesn't come with clear directions.

(2018)

ADRIENNE RICH'S
MUSICAL ETHICS

If you want to change the world, why write poetry?
The great Adrienne Rich, who should have won a No-
bel, tried to do both. Ethics, however, for Rich, stood
at a remove from amoral sonic pleasure. Poetry's sys-
tem of cultivated sounds was, she grew to feel, a patri-
archal racket. Her career staged a revolt against tamed
sound. Of this conflict—the attempt to reconcile mu-
sic and ethics—she founded a perpetually astonishing
body of work, filled with battle cries, conversion scenes,
and illuminating flashes. She followed Walt Whitman's
example—drawing on her own bodily experience, but
also exercising, like a census-taker or compassionate so-
ciologist, a democratic wish to compose litanies of repre-
sentative specimens.

Curmudgeonly purists criticized her work's political
(lesbian-feminist) core. They ignored the fact that she
chose to honor poetry by performing societal inquiries
in verse lines that always remembered, in their sinews,

the exaltations and laments of such noble elders as John Keats, Langston Hughes, and Emily Dickinson.

Rich's work wears veils, but the private life leaks out. We glean that she had a Jewish father (a pathologist) and a non-Jewish mother (a pianist); a sister; three sons; and, for a time, a husband. (Read her groundbreaking *Of Woman Born*.) We know that the husband killed himself in 1970. (Read her aching poem "From a Survivor.") We know that she took on a public commitment to lesbian identity and to the struggles against sexism, racism, colonialism, classism, ageism, homophobia. We know that she lived with physical disability: "I write this / with a clawed hand." Confessional poets (Sylvia Plath, Anne Sexton) were once her peers, but Rich steered clear of their hectic charm and flashy, gnarled gregariousness. Rich tempered passion's eruptions with reason, rhetoric, severity, and a dislike for everything slack, sybaritic, and exclusionary.

Rich, like John Ashbery, was anointed by W. H. Auden, who picked their books, in different years, for the Yale Younger Poets prize. Both Rich and Ashbery remained lapsed Romantics—turning to nature as counterpoint to doldrums. Ashbery chose fractured pastoral; Rich extracted metaphors from geology, archaeology, astronomy, and biology.

Rich began her career writing neoclassical lines that Robert Frost might have applauded; by the late 1960s, she had plunged into a breath-based, open-field prosody.

Iambic upswing offered a consoling pulse Rich couldn't repress, but she spiked her iambs with the bitters of broken lines, of staggered, unpunctuated utterance. At the arts of persuasion, Rich worked as hard as Demosthenes on the shore, pebbles in his mouth.

Gertrude Stein wasn't part of Rich's pantheon, but stylistically, they were kin: they shared steeliness, transformative rage, and the self-confidence of genius. Rich grew up in Baltimore, with a doctor father who taught at Johns Hopkins, where Stein had studied medicine. Both women, prophets of stifled passion, went to Radcliffe. Their commonsensical sentences tended to command. Rich and Stein knew that sometimes a sage's job was to construct riddles.

As her sibylline method of dismantling patriarchy, Rich trusted, with visionary conviction, the senses—the evidence of heartbeat, blood-flow. She trusted her body's messages; she also trusted the body of the reader, the "you" that her poems plangently addressed:

> If they call me man-hater, you
> would have known it for a lie
>
> but the *you* I want to speak to
> has become your death

Reading Rich, we become the posthumous *you* she ardently addresses; we willingly occupy the hot seat of audition.

Rich's poems, staged within her investigating mind's planetarium, bundle together imagistic enigmas, and then pierce the fog with plainspoken moments of reckoning, her syllables paced, lucent, stentorian: "But there come times—perhaps this is one of them— / when we have to take ourselves more seriously or die." The unconscious didn't seem to play much part in her work; instead, she chose daylight. To change the world, a poem needs to state its points with blistering simplicity. See the heartbreaking end of "A Woman Dead in Her Forties": "the body tells the truth in its rush of cells / . . . I would have touched my fingers / to where your breasts had been / but we never did such things." This avowal may be intimate, but she pitches her voice to echo in the amphitheater. No gesture, in her carefully wrought poems, ever seemed accidental; and yet, starting in the mid-1950s, she dated each poem, to mark it as revocable way station.

Rich performed her ethical mission by writing lines sensitive to the pulsations and textures of material fact: animal, plant, human, stone, water, planet. Her politics, not abstract, took place in blood vessels. Precarious ecologies stirred her sympathies. Rich was a natural historian with an ear for the music that politics makes in the body. Listen to her long vowels and keen consonants; listen to the leitmotif of pain. Note the physiologies of words like "crevice" and "gobbets," "shearing" and "vetch," "scours" and "debridements," "pelt" and "cumbrous," "juts" and

"bleak glare aching," "rootsuck" and "glare-lit," "crenellated" and "burdock," "pleated" and "mazed," "grief-tranced hand" and "the slow-picked, halting traverse of a pitch." Rich concentrated her music; necessary, dubious, it incarnated her earliest hopes.

Listening to Rich's vowels and consonants, we hear her ethics. Racism and patriarchy have pillaged a natural world she elegizes; amid mourning, she intones (in a voice disbursing consolation) such lancing phrases as "the lake's light-blistered blue," "the soaked wick quietly / drinking," "striated iris stand in a jar." Nor forget "crimson stems veining upward" or "the dry darkbrown lace of seaweed." Observe "the bridgelit shawls" and the "sycamores blazing through the sulfuric air." Pay homage to "firegreen yucca under fire-ribbed clouds / bluegreen agave grown huge in flower" and the spectacle of "bloodred bract from spiked stem / tossing on the ocean." Learn from a rainbow "arching her lusters over rut and stubble."

Join the perverse visionaries whom Rich salutes in "Natural Resources":

> My heart is moved by all I cannot save:
> so much has been destroyed
>
> I have to cast my lot with those
> who age after age, perversely,

with no extraordinary power,
reconstitute the world.

Disavowed theatrics accord Rich a tone of oracular power.

In public readings, Rich recited her own poems with indelibly sonorous clarity. No listener could fail to be haunted by her deliberate voice, with its trace of a Southern (Baltimorean?) accent. A voice at the podium and a voice on the page are not the same thing; but the grain of her voice can unlock her poetry's sometimes Cartesian heart. Listen to Rich hearing herself—testing herself, investigating her own capacities—in such phrases as "water-drop in tilted catchment" or "gentleness swabs the crusted stump." Precisely calibrated poetic speech is a poultice.

In "Storm Warnings," the first poem in her first book (*A Change of World*), published when she was twenty-one years old, she describes herself as a clairvoyant "knowing better than the instrument / what winds are walking overhead." She became the instrument who could register the tempest's oncoming force. Storm—as planetary crisis, as political revolution, as sensual upsurge—was her vocation. If you have never read Rich, begin with "Storm Warnings." Read it aloud. Try to imagine a country where a poet like Rich is the lauded anchor a populace could trust, in its quest for policies more solid than superstitions.

(2016)

I DON'T UNDERSTAND SHAKESPEARE'S SONNET #154

I don't know who the love-god is or why he's asleep. I
don't know why a branding iron inflames his heart. I don't
know why chaste nymphs shop for keepsakes and then
throw their souvenirs in the Thames. I don't know why,
ransacking a shtetl closet, I found cocaine in a mink
coat's pocket (as if the laden article were a relic from an
Isaac Bashevis Singer story I'd misremembered). I don't
know why the pianist lit a votive candle: to aid her seduc-
tion of my chaste worthless body in the mountain chalet?
I don't know why Dad came down with Legionnaires'
disease and re-proposed to Mom, though she'd long ago
exiled him and pronounced him false. I don't know why
Buster Keaton (my nickname) desires no one, only a
cocktail sign neon-lit in the Nevada desert. I don't know
why virgins keep their virginity, or why ephebe butts are
considered cute near graduation time, or why it is the re-
sponsibility of bucktoothed coloraturas to apostrophize a
novice rear's rotundity. I don't know why the painter put

her prosthetic arm on the seminar table and then asked a pert question about blindness, or why I sang "Suicidio!" off-pitch as substitute for vespers. I don't know why my Sunday School teacher Mrs. Forkash was prettier than the previous year's Sunday School teacher, or why minor differences in prettiness are as solemn as state secrets. I don't know why taking a bath with my brother provoked no hard-on, at least not a hard-on I can remember, and I remember every hard-on, especially the kitsch ones, the nepenthe ones, the hard-ons that have the power (even in retrospect) to eviscerate my will to survive. I don't know why after kissing the ailing man my lips felt tingly and chapped, as if I'd covered them with Tabasco sauce. I don't know why the sick man allegedly found his trick in the library basement, and why I imagined that the death-bringing trick was well-hung. I don't know why smallpox on blankets creates genocide, but I know a genocide when I see one, and I'm the poet here; I'm the loser who gets to decide how the poem ends.

(2014)

MY BRIEF APPRENTICESHIP
WITH JOHN BARTH

In fall 1980, when I was twenty-one years old, I moved to Baltimore to study fiction writing with John Barth. I finagled a cheap apartment on East Eager Street. Among my dwelling's quirks was a hole in its bathroom wall. Through that aperture I could see into the adjoining apartment, where my neighbor often walked around nude. One evening I visited this naturist; he showed me his gun collection, arrayed on a coffee table. There is no good reason to mention that detail here, except that I re-member it as vividly as I remember everything else from my year in Baltimore, and because my East Eager Street studio, with its vistas and its squalors, seemed the dank antithesis of what I experienced at Johns Hopkins Uni-versity in Barth's classroom, where I underwent an ease-ful, daunting, and lucid initiation into prose's Eleusinian mysteries.

✦

This essay is composed in "crots," a rare term I learned from Barth. A crot is a separable unit, like a paragraph, without connection to the units before or after it. Each crot is its own event. We leap from crot to crot, at liberty; connections arise through juxtaposition, not through direct statement or overt linkage.

✦

Before moving to Baltimore, I prepared by reading Barth's *Lost in the Funhouse*. Its pages shone with strange juxtapositions. "Plush upholstery prickles uncomfortably through gabardine slacks in the July sun. The function of the *beginning* of a story is to introduce the principal characters, establish their initial relationships, set the scene for the main action, expose the background of the situation if necessary, plant motifs and foreshadowings where appropriate." So went the title tale, its *haute* postmodernity my first taste of the new pleasure to be taken in warm coldness. I read Barth's specular "Life-Story" at a café in Cambridge, Massachusetts, while drinking French roast coffee made in a French press machine. From Barth's book I learned a word that would become my touchstone: *glossolalia*.

✦

The first day of the seminar, Barth introduced us by mentioning each student's exemplary trait. One of my classmates had won a fiction prize from *Mademoiselle*. What was my signature accomplishment? Barth said, "Wayne has high GRE scores." I remember thinking, "My scores aren't particularly stellar."

◆

"Not particularly stellar" is an apt description of the fiction I wrote that semester. Barth never directly offered verdicts; he commented punctiliously on matters of form, tone, diction, perspective, and plausibility. He never said "not particularly stellar." That phrase is my own.

◆

Barth informed me that I was a surrealist. Maybe he never used the word *surrealism*, but he indicated that my stories emerged from an indwelling force, my portable furnace of dreams and fantasies, whose byways were not easily converted into convincing narratives. He encouraged me to read John Hawkes, whose novels prodded me to practice a more fluent oneirism. From Barth's diagnosis of my surrealism, I understood that he was drawing a distinction between two kinds of

writers—those who believed in the experiential world of phenomena, and those who believed in the imaginary, unseen world of noumena. (I'm botching the philosophical terms.) Barth helped me realize that I was a carnivalesque numen-seeker rather than a canny constructor of stories. The home I would find in the erotic turgidities of the unconscious—even as exemplified in a French press coffee machine—was a location that Barth, in his subtle way, guided me toward, by recommending Hawkes and by diagnosing my dream-prone impracticality.

✦

Barth told me that I had good grammar. I gathered from this comment that I participated in the concrete, phenomenal world through linguistic impeccability, even if my motives and inspirations were chthonic. I had not yet made the transition from Anaïs Nin's *House of Incest* to Djuna Barnes's *Nightwood*. Barth introduced me to a world of experimental, chimerical literature that could rely on schemes as well as on serendipity. By commending my grammar, Barth obliquely gave me the go-ahead; on the surface at least, my stories were clean.

✦

That semester, I was trying to live wildly; the nuts and bolts of my wild living I'll save for another essay. Some of those excursions leaked into my fiction, though usually messed up by melodramatic exaggeration. One of my stories opened with a sexual murder—my attempt to be *noir* and to express allegiance to an erotic underground. Barth wrote in my opening paragraph's margin: "You've certainly got my attention here!" I took his comment to mean that I was overdoing it; maybe he was amused by my Sadean gesture's punk audacity, despite its purple coating.

✦

After learning that Barth liked opera, I developed a fantasy of becoming, overnight, a successful tenor; in my flight of fancy, I starred in *La Bohème* at a summer festival on the shores of Chesapeake Bay. The fantasy acquired a disturbing intricacy: in one version of my pipe dream, I imagined trying out a Puccini aria in the seminar and seeing Barth's face light up with admiration as he realized that though I was no great shakes as a fiction writer, I had a knack for singing verismo.

✦

The final day of the fall seminar (my last day studying with Barth, who would take a sabbatical in the spring),

he brought his drafts and notebooks to show us what a novelist's raw materials looked like. I'd never before seen a famous writer's manuscripts; nor had I ever thought with sufficient concreteness about writing as a physical event that leaves a trail of material traces. Barth's show-and-tell episode introduced me to the addictive mysteries of what Derrida called "archive fever," a temperature I'm still running.

✦

The first day of the fall semester, Barth told us four important things—lessons I've never forgotten. Boastfully I repeat these credos to my students: "John Barth once told me . . ." And now I will pass on these lessons to you.

✦

The first lesson: Barth said that we needed to figure out our aesthetic position. He referred to us as apprentices; the most important part of our apprenticeship was deciding our stance toward narrative art's basic tenets. He never said, "Your task is to become a better writer." Improvement was not the goal. Our aim was to take a stand on the issues that governed contemporary literary production. Would we be realists? Fabulists? Minimalists? Would we invent a style that corresponded to no prior

model? (I remember him saying, as a gesture of praise, "Joyce Carol Oates writes all over the aesthetic map." I, too, wanted to be promiscuously nonsectarian.) As if figuring out whether or not to embrace atheism, we would search within and we would investigate without; we would ruffle the universe's feathers with our stylistic questionings. After a long *voir dire*, we would conclude: "I believe in the power of nouns to represent things." Or: "I will be Molly Bloom, afloat on arioso." Or: "I will write plain sentences, governed, like Walter Abish's *Alphabetical Africa*, by rules." I read *Alphabetical Africa* after hearing Barth mention it. I never became wholeheartedly Oulipian, though an aura of constraint surrounds everything I write, however untidy it seems on the surface.

✦

The second lesson: Barth told us that we needed to decide whether we believed in stained glass or Windex. Stained glass writers considered their texts to be embroidered opacities that concealed reality. Windex writers believed that language was a transparent glass that gave unflecked access to the face of things. Stained glass versus Windex is still the way I divide the literary world. Toward stained glass my loyalty remains, though today I feel very Windex. And yet I've spent so many years devoted to stained glass that even my Windex moods contain a latent

opacity. Even when I try to be transparent, my intrinsic tropism toward ornamentation turns clarity into cloud.

✦

The third lesson: Barth invoked a golden age (the early 1970s?) when his students had been obsessed with experimentation and had produced hybrids, parabolas, nonce contraptions, nutcase devices. I pictured students bringing milk crates to class and demanding that the crates be considered fictions. Now, Barth said, students had returned to realist fiction. His tone, as he gestured toward that golden age of revolutionary praxis, was ironic though wistful; perhaps he was relieved now to be facing a class of tame fictionists. *Fictionist*, I believe, was his word. Fictionists—like structuralists or paleontologists— occupied an arcane guild, guarding trade secrets, and devoted to sacred intricacies of manufacture. As apprentice fictionists, Barth proposed, we could afford to leaven our Wagnerian ponderousness with a Nietzschean taste for pranks.

✦

The fourth lesson: read Aristotle's *Poetics* to learn the foundations of dramaturgy. Even the most experimental stories—Barth mentioned the works of his similarly

named peer Donald Barthelme—obey the rules of dramaturgy as codified by Aristotle. Dramaturgy meant recognition scene, tragic flaw, and reversal of fortune. I doubt that my writing reflects the gravitational pull of dramaturgy, but I have never stopped thinking about that word and its power to summon the seriousness of the tale-spinner's vocation. I may not pay sufficient attention to the unseen structures that govern narrative, but I try to be serious. Right now I am in the midst of a sober *anagnorisis*.

◆

How tight and electric the atmosphere in Barth's classroom was, how vigilant the air, how clarifying the climate! (Think of Katharine Hepburn swimming in the matutinal Atlantic.) Our seminar's atmosphere reflected how rigorously Barth had mused about the craft of fiction, how unsentimental and empyrean were his mental paradigms. "Empyrean" makes it sound as if sacrifices were entailed—when in fact the pleasure of Barth's pedagogy came from his contagious sense of how liberated we could be from inherited structures, how open the art of fiction was to our intrepid accidents, as long as we remained heedful of ancient dramaturgical foundations, pillars upholding the temple. (The classroom may have been in the basement, but my aspirations were in the cupola.)

✦

Barth in seminar had the absorption and efficiency of a logician. I've never achieved, as teacher, his intensity of focus and his air of supreme relaxation. In the spirit of Wallace Stevens's "supreme fiction," Barth as pedagogue conveyed a delight in abstraction's Apollonian suchness. When I think of him at the seminar table's helm, offering his gentle sagacities, I envision a seasoned equestrian, who can ride without haranguing. Good pedagogy reproduces D. W. Winnicott's notion of a holding environment, a necessary enclosure provided by a parental figure's indestructible presence. Barth created a holding environment, though it wasn't sappy. We were held in place— within a serene justness of accommodation—by his reticence, like the modesty of a charismatic host who will not direct his guests toward any specific choreography of seating or promenading. We were free to move and write as we pleased, but Barth's principles—modernist at core, practical as the Bauhaus, with rococo Scheherazadian playfulness piled on top—environed us with an impression that we were ambling through a cloister's open-air arcade, an architectural setting in which contemplation, quietness, sanity, and devotional single-mindedness determined how we positioned our roving imaginations.

✦

From Barth in person I learned what I had earlier gleaned from the poems of Ezra Pound: simplify. *Moisten*, Barth said, was the right word to use, not *moisturize*. He described *moisturize* as an unattractive neologism. I am guilty of many semantic sins, along the lines of *moisturize*. But I always try to maintain fealty to the principle that *moisten* represents.

(2015)

TWELVE ASSIGNMENTS

1.

Play a recorded piece of wordless music that you know very well. Listen to it once. Then, turn on a microphone that can record your speech, and listen to the piece again. Deliver an impromptu monologue while the piece is going. Afterward, transcribe your soliloquy.

2.

Go to a museum or gallery and choose a work of art. Stand or sit in front of it. Write for ten minutes (without stopping). You needn't mention the work of art.

3.

Take notes while talking to someone on the phone. Afterward, transform your notes into a story.

4.

Find a telephone book. Write a poem using as many names as possible from the yellow pages.

5.

Watch a silent film. (Suggestion: F. W. Murnau's *Nosfer-atu.*) While watching it, take notes. Transform your notes into a composition.

6.

Ride a city bus. Get a window seat. Write down any words you see out the window. Go home and transform those notes into a two-page piece of writing.

7.

Write about the potatoes in Chantal Akerman's film *Jeanne Dielman, 23 quai du Commerce, 1080 Bruxelles.* Or you can write about any other specific object (or category of object) in any film.

8.

Buy or borrow a copy of the longest book you can find. (Suggestion: Robert Burton's *The Anatomy of Melancholy.*) Begin reading it. Start anywhere you want in the book. After a half-hour of reading, write for ten minutes; include, in what you write, at least one phrase from the long book you chose to be your composition's incidental catalyst.

9.

Make a list of names—first names—about which you have negative feelings. Choose one of the names—or

more than one—and take fifteen minutes to write about
the negative associations.

10.

Begin to collect objects of a certain kind. Matchbooks.
Pennies. Empty Kleenex boxes. Or something more
beautiful, esoteric, captivating. After you have collected
enough specimens—whenever you believe that point has
been reached—write a brief inventory of the objects.

11.

Describe an ungenerous or unkind act you have commit-
ted. The act could be merely verbal.

12.

Take a pair of scissors, and cut out—very quickly—some
random shapes from found pieces of paper, cloth, plas-
tic, or other flexible materials. Assemble a small village
of these fragmentary shapes. Write about that village, its
inhabitants, its secrets.

(2015)

IV

SIX STARS

1. Swimming with Nicole Kidman

A few days before the Oscars, I swam next to Nicole Kidman. This is not a lie. We occupied adjacent lanes. She was really Nicole: I'd seen her ID card at the lifeguard's station. The star's skin, underwater, was pearly blue-white. While swimming, she wore a loose shirt (for modesty?) and kept her head above water, to protect her nascent hairdo from chlorine and dissolution. A few days later, at the Oscars, her hair was swept back and up into a tight chignon, like a caboose, but aloft. I am not in love with Nicole Kidman, nor am I in love with her hair; but I am in love with the fact that I saw her in person underwater and that a few days after this encounter she appeared at the Oscars.

✦

Nicole Kidman is not a spokesperson for high hair. But her attitude toward her hair (her tendency to keep it back and piled) is consonant with high-hair philosophy. Pulled

behind and up, the hair expresses a dominating tempera-
ment, temporarily restrained by politeness or strategy.

✦

Nicole Kidman no longer swims in my health club's pool.
She has taken her high hair elsewhere. But my fantasies
about high hair's power to demolish and uplift the spec-
tator have remained stationary.

2. Annette Funicello Circumlocutions

Annette Funicello, who starred in the 1960s TV show
The Mickey Mouse Club, occurred to me this morning while
I was watching a bee stumble into the center of a sloppy
rosebud—a type of rose I call "beach rose" (though in truth
it is a rugosa rose); I used to see this species of flower on
the road to Hammonasset Beach, where once I observed
two men undress in the cubicles near the showers. There is
no logical connection between Annette Funicello, a beach
rose, an inquisitive bee, a beach's cubicles, and the men who
long ago stripped, under my inquisitive gaze, in the vicin-
ity of weakly sputtering public showers. When Funicello
enters my beach-rose-abutting consciousness, I do not bar
her entry: I invite her, in her capacity as hovering word-
less shadow, to dominate my mood. I grow more precise

in the imaginary presence of Annette Funicello; and yet
I also grow more blurry. To Annette Funicello I owe my
oscillation between blur and acuity; to Annette Funicello I
owe my command of clear edges, as well as my surrender to
haze. And yet I owe her nothing. I invited her into this es-
say's room. I resuscitated her, and asserted her timeliness.

✦

My older brother played cello—plays it still—but had
no fun playing it. Or did he have fun playing cello? Do
I slide into the funnel of reminiscence by finding Funi-
cello? Funicello is where you and I encounter each other.
Funicello is the beach cubicle and the map to the cubicle.
Funicello—as a sign, a career, a body of theatrical work,
and a reputation—Funicello as a saucy and concrete
imago—is the only real raft I can cling to in this ocean of
pointless saying. My prose is alive only because it repeats
Funicello and thereby, through the ear, summons your
collaborating presence. Fundamentally I need Funicello
so that I can make sense; Funicello is the rock around
which these dimensionless periphrases circle. In the pres-
ence of deliberate circumlocutions Funicello sends out
her clear light; she sends out shadow, too. What happened
to the men changing into their bathing suits at Ham-
monasset Beach? What will be the fate of the beach rose
I observed this morning, and the identityless bee that

the rose contained and hosted? I earn legitimacy—I steal tether—by summoning Funicello without explaining Funicello; the freedom not to explain Funicello is the plushest lounge I've encountered in my long search for wayside venues willing to host my void-entranced calisthenics.

3. Madonna's Usurpation

Many were the times, in the 1990s, that I drove to the beach, while spinning, on the car's CD player, a Madonna compilation, "La Isla Bonita" seeming the theme song of my own flight into the sun's narcotizing ability to stun any realistic thought out of my head. "La Isla Bonita" promised a fantasy escape to an island—an exclusive club— that wouldn't grant me admission. I didn't feel attractive enough to belong to "La Isla Bonita," but the song's derivativeness (in its derivativeness I locate my pleasure) entitled me to feel I had the right to a sloppy, secondhand membership in whatever erotic festival that the song, and Madonna herself, embodied. When *Desperately Seeking Susan* was first released, I felt that Madonna was getting more attention than Debbie Harry, but that Madonna was less beautiful and less vocally subtle than Harry. Madonna was a usurper. I should have loved Madonna's shallowness, and her canny manipulation of it. Instead, when Madonna rose to fame, I already was in mourning

for Harry as a figure beginning to experience premature obsolescence. I'm a headstrong student of star culture; in that school, I matriculated early. (At age four.) And, at the beginning of my studies, I understood that obsolescence was the preferable liqueur, even though the world might condescend to superseded figures. Why I love the obsolete is a long story. Longer, perhaps, is the story of why I think it is my mission to convince the world to love the obsolete.

4. *Taylor's Tweets*

Dame Elizabeth Taylor was the moniker under which the star tweeted. I believed these tweets—believed in their authenticity; believed that they emerged directly from the star's consciousness and will. They seemed trustworthy emanations from a heretofore inaccessible nugget of Liz-consciousness. I remember the instant of shock when I happened upon a Liz tweet (or a "Dame Elizabeth Taylor" tweet) for the first time, and felt touched by her sudden proximity. Now that moment strikes me, in retrospect, as an overly credulous surrender to a fiction of star-presence. Liz wasn't *really* there, behind the tweet. I was being hailed by a seductive illusion, however tangentially grounded in the actual directives and words of the Dame herself. Had I tried to respond to the Dame with a tweet of my own, I'd doubtless have been disappointed by the impossibility of

reciprocity. She could hail me, from behind the fortress of her star machinery; but I lacked the power to hail her.

5. *Omar Sharif Jr. in* Being and Nothingness

Recently I started using Instagram. At first, I posted under a pseudonym: "dans_les_ruines." The phrase comes from a Gabriel Fauré *mélodie*, "Dans les ruines d'une abbaye," set to a poem by Victor Hugo. I didn't want to post as myself; I chose to post as a ruin, a French-tinged trace. I posted under the guise—the alias—of a fragment from a poem long ago set to music and now forgotten.

✦

For one of my Instagram posts, a digital collage, I downloaded (from the internet) a photo of Omar Sharif Jr., an openly gay star, who happens to be the grandson of a more famous actor. Using Photoshop, I juxtaposed this photo of Sharif *fils* with the phrase *Being and Nothingness*, snipped from a downloaded photo of the title page of Sartre's tome, translated into English. One hashtag for my post was #remakes. Another was #beingandnothingness. Another was #omarsharifjr. The title of my post: "Omar Sharif Jr. in *Being and Nothingness.*" A few days after posting this fictional film-still from an imaginary remake of a book, *Being*

and Nothingness, which could never plausibly be the basis of a film, I was pleased to discover that Omar Sharif Jr. himself "liked" my post. Omar Sharif Jr. has an Instagram account; whoever is in charge of that account "liked" my post. Did Omar himself see my collage? Did Omar appreciate it? Or did someone who works for Omar see the post? In any case, I experienced a tiny, unverifiable instant of star-reciprocation—an uncanny greeting from a man who represents the becoming-spectral of a "stardom" originally represented by his grandfather. Out of the nothingness of the internet abyss, which poses as community, I felt Sharif's touch, and I became, momentarily, a confirmed Being.

6. Liza in Rehab

I wasted the last fifteen minutes online reading a comment thread, tortuous and arcane, attached to a *People* magazine account of Liza Minnelli checking into rehab. The article averred: "The actress, 69, has already checked into the facility, the name of which is not being disclosed." Many of the thread's grousers attacked issues of spelling, punctuation, grammar—mistakes made not by Liza but by online bacchantes. One anonymous visitor complained: "to troll, you need to be at least partially mentally competent and speak English people can understand." Another said: "Are you joking or do you really spell like that?" Another: "The slaughtering

of the English language is so sad." Another troll offered: "You seem addicted to capitalizing everything. Learn some grammar and punctuation. And stop whining. It's a turn off." Another anonymous quibbler offered: "Some people don't understand what Caps are for. It's really strange. She also begins sentences with 'Because' so clearly she has more issues than just Caps." The "she" in that sentence refers to an online troll, not to Liza. As far as the comment-thread writers are concerned, the problem is not Liza's addiction but language's addiction to its own procedures of consumption and correction. Who is in rehab, Liza or the sentence? Stardom and its fallout are verbal matters, O attentive reader. How stars behave—how stars behave *inside us*, after we have introjected them, or swallowed their stories whole—is subject to linguistic laws. We find stardom in our bodies as a verbal residue in need of arrangement and arraignment. Jurisprudential issues (crime and punishment, obedience and reward) surround the arrangement of words: call it syntax, call it punctuation, call it spelling. Am I here? My presence is up for grabs, as up for grabs as what happens inside or outside the body of any star whose image seems to tell a simple story. Spelling a name and discovering an identity are tricky matters, exceeding the reach of any reader but the most ashamed. Remember *Liza with a "Z"*? Isn't Liza—and every principle that her stardom, or anyone's stardom, in or out of rehab, represents—always stuck with the job of giving spelling lessons?

(2005–2017)

CELEBRITY'S SECRET
AMELIORATIONS

I.

I'll add my two cents as a devil's-advocate defender of celebrity's secretly salvific tendencies. I know that celebrity is a capitalist or post-capitalist toxin; I know that civilization is disappearing down celebrity's hole. I recognize all the arguments against celebrity. I understand celebrity's connection to fascism: citizens worship the Leader simply because the Leader's face is recognizable. Celebrity, as a subject, depresses me; and yet I feel compelled to rise to its defense as an aesthetic playground, a zone of carefree libidinal intensity. (For some spectators. In some circumstances.) I speak as a cannily retardataire mystic; as a surrealism-oriented advocate of unconscious energies; as a haruspicator of celebrity entrails; as a prurient detective; as a close reader of celebrity faces.

2.

Above all, I bring to you one simple argument (although in general I avoid arguments): for good reasons we may

condemn the culture of celebrity, but in the contemplation of human faces (famous faces lend themselves to reverie and close study) I find aesthetic grail, solace, complexity, absorption, wonder.

3.

No. That sounds too old-fashioned. Let me say, instead, that human faces (especially beautiful faces, or faces that a culture defines as beautiful) are ideal subjects for time-bending contemplation. Studying a face, we stop time. And the exercise of *stopping time* is one avenue available to a human being in search of amelioration.

4.

We're stuck in human bodies, with human faces, and the only way out of that dilemma is to study (to memorize, to adore, to stylize) a human face and a human body.

5.

The recognizable face—the celebrity face—is merely an object for attentiveness; a visual token; a retinal mantra. A pair of cheekbones. Eye sockets. Eyelashes. The space between eye and ear. The horizon of the hairline. The reef of the nose.

6.

For many years I gave embarrassingly serious thought to the face of Jacqueline Onassis. I tried to justify that

seriousness, to rationalize it. But I didn't say clearly enough that the reason that I allowed her image to occupy my consciousness and to dwarf all other prudent and moral considerations was simply the fact that on her face (as given to me by the media, usually in still photographs, not moving images) I could spend time and thereby *stretch* time. I didn't say clearly enough that the reason I loved Jackie's face was that media artists (paparazzi, magazine editors) had given it to me, and that this face had a spaciousness, a blankness, a beauty, a tranquility, a sameness-to-itself (always the same Jackie-face) that allowed me to treat it as a sanctuary, a point of embarkation, a port to which I could perpetually return, if only to find nothing there, or a something so full of implication that its cacophonous innuendos coalesced to form a zero.

7.

Aren't we biologically programmed to respond to human faces? And, if we're shown the same face, again and again, a silent face, a face in photographs, aren't we (against our wills, against our better judgments) liable to develop tranced emotions in response to it?

8.

There are worse crimes than loving human faces, or succumbing to the lure of a familiar (meaningless, spacious, trademarked) face.

9.

Maybe it was a technology like Photoshop (*avant la lettre*), or retouching or airbrushing, that gave Jackie's face, in photographs, its shininess; contemplating her face, I was responding less to her celebrity than to the visual properties of her cheeks, hair, and eyes, as photographed entities. I have often used the word *shine* (a word with philosophical complexities, at least in German, where it intersects with ideas concerning appearance, being, semblance) to describe the non-matteness, in Jackie's cheeks and eyes and hair, when photographed, that drove me into chambers of stopped time, internal reverie-aquariums; *shine* has become for me almost a holy word, or a thought-stopping word, to describe the way that the space between an eye and an ear, or the space between the hairline (at the forehead) and the coiffure's summit, forms a prairie or plateau. Look at a photograph of your favorite celebrity's face; find the face's blank zones, the places where a certain non-differentiation takes hold. Find the places where the "known" aspects of the face intersect with a dumb, unsentient absence. Cheek, before it reaches the eyes or the nose, is merely cheek; cheek has no identity. I have sought in the celebrity face those zones where identitylessness flourishes in the midst of trademarked identity.

10.

Sometimes I find those oases of identitylessness in the celebrity's eyes, especially when the eyes don't stare forward but swerve to the left or to the right, as if avoiding the camera. At those moments of *looking away*, when caught by a photograph, the eyes reveal mostly white, the iris decentered. Looking at the whites of celebrity eyes, I see an abstract zone, an interstitial region not exactly beautiful but arresting, usable. I can use the white of the celebrity eye as a lotus-eater's isle, as a rest stop on locomotion's (or intellection's) dreary highway. I can stop being a self. And I can become, instead, a contemplator of the white of the celebrity eye, the part of the eye that can't see.

11.

You could accuse me of being a self-deluding fetishist, savoring a human body's displaced zones, whereon I can project my own internal objects. If you offer that critique, you'd avoid the truth of my testimony, and its applicability to your own plight. If you brand me a fetishist who exercises too freely his flights of fancy upon the helpless figures of the famous, then you'd ignore your own potential tendency to lose cognition's grip by falling under the sway of a stranger's eyes, cheeks, mouth, nose, hair, tongue, teeth, chest, legs, feet.

12.

Consider a widely disseminated photograph of actor Sacha Baron Cohen—star of *Borat* and *Brüno*—nearly nude on the beach at Cannes. Baron Cohen, famous man, appeared in an embarrassing thong on the beach, his buttocks visible, almost all of his splendid yet weird body available for our speculation—a body nude except for the bare essentials of his "Borat" persona (goofy glasses, curly hair, geeky shoes and socks). When I google "Sacha Baron Cohen Cannes" I get 138,000 results; when I google "Sacha Baron Cohen Nude" I get 130,000 results. (That's not many, for a celebrity.) There are thousands of other nude or nearly nude bodies, famous or not, on whom I could dump my sordid hungers, and so why does Baron Cohen excite from me a particularly intense regard? Perhaps because the internet has allowed me to see the stretch of his thigh as it leads up to the buttock. I can see the thigh reach the buttock and become the buttock itself. And I can think "thigh," "buttock," repeatedly, slowly, but abstractly, because the mechanism of photography and of global information-transfer has acted as a go-between, a chastity belt, a buffer, between my prurient curiosity and the real Baron Cohen. In my scene of looking, celebrity is not the intoxicating agent; instead, celebrity is the anti-inebriant, the mediator, the neutralizer, the anesthetic. Celebrity is a pair of surgical gloves. Celebrity is the prophylactic fabric that entitles me safely to regard Baron Cohen's thighs

and buttocks, but when I study his thighs and buttocks I am not studying celebrity itself, I am studying "thigh" and "buttock"; the fact that celebrity culture brings into my home this vista of thigh and buttock is the grounding premise (the proscenium, the *deus ex machina*) but not the ingot itself, not the desired essence.

13.

I am not interested in Jackie Onassis's fame. I am not interested in Sacha Baron Cohen's fame. I depend on Jackie's fame to bring me her hair, her cheeks, her eyes. I depend on Sacha Baron Cohen's fame (and on his audacity, his exhibitionism, his wily, Dada-esque use of the media as an arena for blitzkrieg performance-art interventions) to bring me his thighs, his buttocks. Fame is the assembly line, but it is not the commodity traveling down the conveyer belt. The commodity is eye, hair, nose, thigh, buttock. The mystery is why we need celebrity to convey to us, in media wrapping, these essential comestibles.

14.

I speak as someone starved for eye, hair, cheek, mouth, nose, thigh, buttock. Are you already sated with these viands? Are you not in an emergency state of perpetual need, a craving easily satisfied by the celebrity body? I stage my hunger—I exaggerate it—for communication's

sake. I amplify my desire so that its clown-like volume might strike, in you, an answering echo.

15.

I bring to the act of studying the celebrity face the same taste for absorption, the same appetite for trance, the same willingness to magnify incidental details, that I bring to the contemplation of visual art, including abstract paintings. I look at an abstract painting with the same rapacity for detail (and for a Lethean obliteration-of-minutiae) with which I look at a photo of a beautiful star.

16.

Hypothesis: we crave the celebrity face not because of that face's qualities or associations, but because it is a face we have already seen. We enjoy, in this face, the fact of having already witnessed it. We enjoy the face's pastness, its identity as recalled object. Uselessly we crave figures we already know, places we have already visited. Deeper than nostalgia, perhaps, is this desire to retraverse, to experience *recognition*. Consuming the celebrity's image, we consume our recognition of it. We consume our own sensation of comfort at having returned, at having landed somewhere indubitable.

(2011)

AN EVENING OF SCREEN TESTS

Start with Judy Garland. In her wardrobe tests for *Valley of the Dolls* (1967), a film from which she was eventually fired, she comes across as a charmer—lighthearted, cooperative, problem-free. On her behalf, I want to start campaigning. I want to lobby for a remake of *Valley*, this time with Garland restored to her role as wig wearing Helen Lawson, a part that destiny gave to Susan Hayward instead. And I want to militate for a worldwide reinterpretation of Garland, the court of public opinion this time passing a "not guilty" verdict on her depressive tempestuousness. Garland screen-tests my eligibility for the role of interpreter who rescues tarnished goddesses, though Judy may now wish to excise me from her posthumous entourage.

✦

Barbara Lapsley, star of George Kuchar's *I, An Actress* (1977), is no Garland, but she rivals Gena Rowlands. Repeatedly, Kuchar violates the firewall between director

and actor; he wants to teach Lapsley how to emote, how to clutch her breasts, how to writhe on the floor. Maybe she is preparing for an audition, or maybe the audition has already begun. Maybe the audition has ended, and now she is actually playing the role. Maybe Kuchar is the real actress, the film's "I." Watching, we aim aggression at the wig and coat propped like a scarecrow on a chair; wig and coat are stand-in for Lapsley's costar. Maybe our aggression is being screen-tested. Each time the wig, falling on the floor, unmasks a charade that doesn't need unmasking, my heart leaps with elation, as Wordsworth's heart leapt when he saw a rainbow. But there's a photo—"of many, one"—that unnerved me as a child, and I can't help but mention it now: the photo, appearing in Joe Morella and Edward Epstein's 1969 compendium, *The Films of Judy Garland*, supposedly shows Judy as gingham-clad Dorothy in Kansas, but the girl in the photo looks like a wax-museum replica of Judy, or like a different child actress—say, Deanna Durbin's unknown sister, living incognito in a Nevada ghost town. Perhaps the photo is a publicity still, or perhaps it is a fraud, engineered to send us downward into a vortex of identity-undecidability.

✦

In the video *Tape 5925: Amy Goodrow* (2002), the artist Eileen Maxson stars as (to quote from the artist's website)

"an asocial college student with a secret" who "submits an audition tape to *The Real World*." This screen test's highlight is the syncopation that Maxson's mouth and eyes enact: eyes and mouth move at cross-purposes. The mouth announces nerd identity; but then the eyes twinkle, rescuing the face from nerd purdah. Irony flashes up from somberness, one gleam at a time. Maxson (playing Goodrow) obeys an irony-rationing edict: in hard times, the government apportions only a few instants of irony per month to each citizen. Have you noticed that many young people these days keep their faces numb and expressionless? Maxson allows me to understand that beneath a neutralized face may lie volcanic intensities. My daft assumptions about affect deficits are screen-tested by Maxson's tour de force.

✦

I don't have much to say about McDermott & McGough's uncanny *Alice Campbell's Hollywood, 1938*, except to speculate that the name Alice Campbell might have something to do with Warhol's Campbell's Soup and with Frank E. Campbell's Funeral Chapel (Garland's and Rudolph Valentino's way station), and to confess that I am still in the dark about whether these screen tests—a mother instructing different child actresses to make a scrapbook from issues of *Photoplay*—actually come from 1938 or

indeed feature the personages listed in the credits (in-cluding the 1980s-art-world scions Stella Schnabel, Lola Schnabel, and Zena Scharf). McDermott & McDough, as if inspired by the vertigo-inducing projector in Adolfo Bioy Casares's *The Invention of Morel* (which engendered *Last Year at Marienbad*), deny chronology its accustomed sway. The movie's best line—it gets repeated many times—is the mother's. With MGM intonations worthy of Norma Shearer, the mother warns the child, "Be care-ful not to get any scrap paper on the carpet." I don't un-derstand this admonition. Isn't scrap paper easy to pick up? A prohibition against muffin crumbs makes sense, but why deny scrap paper its right to dwell on carpet, in floorboard crevice, or anywhere it wants to reside?

✦

End with Susan Sontag, or Warhol's two screen tests of her elliptical allure. In my perhaps faulty recollection of these documents, Sontag momentarily tries to keep her face inexpressive—a deadened, behaved face, masking its restiveness. Abandoning impassivity, she unabashedly smiles, a big, awkward, star-envying, North Hollywood High School grin. When we can extract a smile from a scornful face, ambrosia seems to rain down from the heavens, as Wordsworth or E. Y. "Yip" Harburg, lyricist of "We're Off to See the Wizard," might have said, had

either man been fortunate enough to read *Against Inter-pretation*. An untimely death in 1850 prevented Words-worth from encountering it; Harburg lived until 1981, so he had a chance. Just now I googled "Harburg Son-tag" to see if I could find a rendezvous between these two American Jews ("Susan Rosenblatt" and "Isidore Hochberg" were the disguises they wore when they first entered the universe), but Google showed results for a different search, "Hamburg Sonntag," Sunday in Ham-burg, tips on how to spend your touristic Sunday in the only German-speaking city that Thomas Bernhard, my role model in rant and reverie, truly loved

(2013)

RAUSCHENBERG'S SQUEEGEE

In the studio, Robert Rauschenberg rolls his shirt-
sleeves above the biceps. Elbow dimples and chunky
arms add up to charm, success, the luxury of being be-
held. Brice Marden, assisting today, beholds him. So
does Mel Bochner, the unseen photographer. Twice-
beheld, Rauschenberg refuses to smile. Images emerging
from his squeegee catch the 1968 sunlight and send it
into convulsions that won't end tyranny. And yet Raus-
chenberg intends to end tyranny by spreading imag-
ery far, in concentric circles, away from his unified self
and toward a multi-souled conglomerate of flutterings
that constitute the "enlarged Bob," the decentered art-
ist, the prolific repeater. Rauschenberg's shoes—black
leather—veer toward finance, respectability. His pants—
are they jeans, or mere slacks?—govern the atmosphere
by refusing to negate the atmosphere. Pants stay above
the fray by being rolled up to expose the Rauschenberg
ankles, clad in "dress socks." His hair, without frill or
flaw, affords a frame. His hair, like Johnny Cash's, takes
a loose, soulful stand; Rauschenberg's hair will permit

pugnaciousness—for ceremony's sake—but would prefer to take a pacifist route by lying down, a protester, in the middle of the highway. *I place my body, a potential victim's, on the road of art history,* the hair of Rauschenberg might say, if it had the will to confess. But his hair remains silent, creating a vacuum to be filled by the volubility of his flannel shirt, which, untucked, has the stalwart élan of a Paul Bunyan theme-park memento purchased for a squalling boy who suffered motion sickness on the merry-go-round; Rauschenberg's flannel shirt proposes a neutral, forestry-oriented consolation. The artist, like Mount Rushmore, occupies a vast, lonely space; his studio is a chapel of the former St. Joseph's Union Mission of the Immaculate Virgin, on Lafayette Street. Many virgins live on Lafayette; Rauschenberg is not among them. Capable of sexual acts we can't sketch here, he solves the mystery of the Immaculate Conception by conceiving his art with Marden's assistance. Marden—hidden, like a bodhisattva, in a corner, lest his beauty overstage the prima donna's—holds God's seed in a headband wrapped around his sweaty brow. The headband—which will appear, a year later, in *Easy Rider,* or will threaten to appear, but then fail to show up—contains a tiny pouch. Sewn inside this pouch, a thimble-sized vial holds the blessed seed, which will trigger the conception of anything you wish to occur. The pressure of a squeegee on a screen is a sensation contained within my wish; a squeegee, when

it rubs against a screen, exerts a steady, hard pressure whose ineffable physicality kills off any imagery that the silkscreen itself will depict. Rauschenberg's unwavering hands enjoy the squeegee's pressure. We pretend to be governed by images; we pretend that images seduce and construct us. Physical pressures, however, have a power surpassing the visual image's. The squeegee dominates and subsumes any image it creates, even if the squeegee, later, vanishes from the scene of conception. Stained and nude, the squeegee will have no biographer. Rauschenberg doubtless loved this squeegee above all others, even if he gave it no proper obsequies.

(2017)

EIGHTEEN LUNCHTIME
ASSIGNMENTS

1.

Go into a store where you would never buy anything (because you can't afford it, because you don't wear women's clothes, because you hate candy and toys), and write a poem about the merchandise—maybe just a list of it.

2.

Stand near the entrance of a church or temple or mosque and make an inventory of what the people walking in and out are wearing. Permit envy, confusion, and desire to enter your descriptions.

3.

Ride the subway and get off at a stop you've never tried. Write a poem whose title is that stop's name. In the poem, include the reasons you'd never disembarked here. Speculate on vistas and opportunities you've forfeited.

4.

In a crowded museum, stand in front of a painting for fifteen minutes and write a poem that includes all the phrases you overhear from fellow museumgoers. Don't describe the painting.

5.

Take an elevator in a building. Not your usual elevator. Not your usual building. Write a very quick poem while in the elevator. Get out of the elevator when you're finished with the poem.

6.

Take a walk and make a list of all the trees you see, identifying each tree ("the birch tree in front of the Clearview Cinema where *Dark Horse* is playing at 5:10").

7.

Find a seat in a public place. Sit for ten minutes. Describe or annotate or simply list some of the noises you hear— not words, just noises.

8.

Strike up a conversation (however brief) with a stranger. Afterward, write down the conversation in as much detail as you wish. Include a description of this stranger

and indicate why you picked this person as your exper-
imental subject.

9.

Find a seat in a public place and write down the first
memory that comes into your mind, especially if the
memory is stupid or embarrassing. After you've written
down the memory, describe where you are seated. De-
scribe the next place you're headed.

10.

Stand up in a public place where you can find a surface
to lean on. Write down the ten people you'd most like to
see today, in no particular order. Give a brief reason for
why you'd like to see each of them. Then mention exactly
where you are standing.

11.

Sit down somewhere and drink a hot or cold beverage.
In the vicinity (within your range of vision) find three
people whom you'd like to meet or whom you find at-
tractive or interesting. Say why. If you can find only one
appealing person, that's OK. If you find none, that's OK,
but speculate why right now there aren't any potentially
enchanting people around you.

12.

Find a magazine or newspaper. Write down a few head-lines or stray phrases, whether alarming, stimulating, comic, or bizarre. Write a short poem, very quickly, using these phrases and little else.

13.

Stroll for five minutes and write down the names of signs, and any other words you see around you. Take another ten minutes and put these names and words into a poem.

14.

Go into a pharmacy. Choose a specific kind of prod-uct. (Shampoo.) Write down fourteen aspects of this substance: brands, ingredients, peculiarities. Compose a fourteen-line poem, each line mentioning one of the listed characteristics. Now you've written a sonnet.

15.

Sit in a park or garden. Write down everything you've done today, starting from the moment you woke up. Be quick. Let the last line or sentence of the poem include the name of an artwork about which you feel ambivalent.

16.

Describe what you're wearing. Why did you choose these clothes? Which item do you like most? What would you

rather be wearing? If you could change one item, which would it be?

17.

What did you eat for lunch? Why these particular foodstuffs? Defend, praise, criticize, mourn what you consumed.

18.

Take a walk. While walking, keep a list of whatever music you hear—tunes in your head, sound systems in stores, songs on car radios. Write a quick poem that speculates on how these tunes predict your future.

(2014)

LITTLE ELEGY

This episode might not be intense enough for your purposes. On a warm autumn day in the mid-1990s, I wandered, seeking unsanctioned stimulation, down West 22nd Street toward the Hudson River. A new world began here: amid defunct warehouses, I discovered three mysterious doors. Pat Hearn Gallery was the middle door; I opened it. Pat Hearn is now dead. In the mid-1990s, when I opened the door for the first time, a young, lanky, bespectacled guy named Daniel Reich worked for her. Daniel is now dead. "Lanky" isn't quite right. Though not tall, he was thin, like an unstuffed puppet, and he seemed nervous inside his body, as if it formed a newfangled cage he hadn't yet figured out how to maneuver. "Art" seemed to crystallize and redeem his confinement; the art surrounding us, the art we both believed in, the art supporting the conversation we launched into, gregarious yet jittery, underwrote our claustrophobia, but also proposed an exit from disembodiment. Daniel appeared disembodied, as I, translating this memory of meeting him, am ambushed by

a sensation of ice—a frozen separation from that mo-
ment of first discovering Jimmy DeSana's photographs,
which, that mid-1990s afternoon, hung on Pat Hearn
Gallery's walls. DeSana is now dead. He was already
dead when I first saw his work. I can't talk about art
without mentioning the people who surround and ani-
mate it, and who turn the mortified object into an op-
portunity for entranced hyperstimulation. These three
figures—personalities, legends, ecstatics—all died young,
and for different reasons. Is there ever a reason? Jimmy
DeSana, 40, AIDS; Pat Hearn, 45, liver cancer; Dan-
iel Reich, 39, suicide. In some photographs, DeSana was
naked; in others, he wore disguises. My favorite photo-
graph was Jimmy, or his double, with his head in the toi-
let. The posed figure wore a white jockstrap and nothing
else. The toilet, not filthy, overflowed with suds. Another
person—also Jimmy?—stood on the toilet's tank; of this
companion, all we could see were his red-striped athletic
socks and his sneakers. The bathroom was suffused, like
a swimming pool, with reddish orange light, a color not
of carnage but of contentment: shame's antithesis. See-
ing this photograph, I suddenly knew that I wanted to
turn my life in a flaming—carmine? scarlet?—direction,
toward keener demonstrations. Photography, so DeSana
indicated, gave us a way to be more transparent, more
theatrical, more diffuse, more divided, more torn apart.
(I never questioned the postulate that a person *wanted* to

be torn apart.) I've torn this paragraph apart and then reassembled it to embody the afterlife of Jimmy DeSana, Pat Hearn, and Daniel Reich, three adventurers committed to provocation, display, transformation, and the private forge—the smithy of art-making—where ordinary materials, including one's own body, treated with patience, delicacy, and formalist procedures of estrangement (aimed at comforting rather than enervating the maker), can create an atmosphere I usually clothe with words like *nudity* or *carnival*, though today I am feeling rather somber and am not quite equal to nudity or carnival.

(2014)

ACKNOWLEDGMENTS

I wish to thank the stellar PJ Mark, for believing in my seaworthiness; the clairvoyant Yuka Igarashi, for choreographing my circus; and my collaborators at Soft Skull— Wah-Ming Chang, Sarah Jean Grimm, Katie Boland, Sarah Lyn Rogers, Michael Salu, Dustin Kurtz, and the entire convivial gang—for bringing this book to life. I am grateful, as well, to the inspiring editors and allies whose assignments, invitations, and suggestions led me to write many of the essays in this book: Thomas Beard, Laura Beiles, Tom Bishop, Gregory Cowles, John D'Agata, Gabrielle Dean, Jeff Dolven, Lee Edelman, D. Gilson, Donatien Grau, Bruce Hainley, Peter Halley, Ed Halter, Charles B. Harris, Sheila Heti, Paul Holdengräber, Heidi Julavits, Christian Kobald, Michelle Kuo, David Lazar, Patrick Madden, Matthew McLean, Michael Miller, Jason Schneiderman, Todd Shalom, Jared Stark, Rita Vitorelli, Nicole Walker, and Linda Wells.

I also thank the editors of the following publications (print and online), in which portions of this book

appeared, sometimes in different versions and under different titles:

After Montaigne: Contemporary Essayists Cover the Essays (University of Georgia Press, 2015), ed. David Lazar and Patrick Madden: "Of Smells"

Allure: "Swimming with Nicole Kidman"

Artforum: "'My' Masculinity Remix"

The Believer: "My New Glasses"

Bookforum: "On Futility, Holes, and Hervé Guibert"

Commie Pinko Guy (Raven Row and Koenig Books, 2015), ed. Bruce Hainley: "Liza in Rehab"

Frieze: "Rauschenberg's Squeegee"

index: "Game of Pearls" (reprinted in *Harper's Magazine*)

The Iowa Review: "Punctuation"

John Barth: A Body of Words (Dalkey Archive Press, 2016), ed. Gabrielle Dean and Charles B. Harris: "My Brief Apprenticeship with John Barth"

Light Industry: "An Evening of Screen Tests"

Merry Art (Hannah Barry Gallery, 2015), ed. Hannah Barry and Donatien Grau: "Little Elegy"

The New York Times Book Review: "Adrienne Rich's Musical Ethics"

Out of Sequence: The Sonnets Remixed (Parlor Press, 2014), ed. D. Gilson: "I Don't Understand Shakespeare's Sonnet #154"

Seneca Review: "The Task of the Translator"

Spike Art Magazine: "The Porn Punctum"

Tin House: "Odd Secrets of the Line"

Ways of Re-Thinking Literature (Routledge, 2018), eds. Tom Bishop and Donatien Grau: "Corpse Pose"

Zeitschrift für Medienwissenschaft: "Madonna's Usurpation," "Taylor's Tweets," "Omar Sharif Jr. in *Being and Nothingness*"

© Tim Schutsky

WAYNE KOESTENBAUM's twenty books include *Camp Marmalade, Notes on Glaze, The Pink Trance Notebooks, My 1980s & Other Essays, Humiliation, Andy Warhol, Jackie Under My Skin*, and *The Queen's Throat*, a National Book Critics Circle Award finalist. A new edition of his first novel, *Circus; or, Moira Orfei in Aigues-Mortes*, was published in 2019. He has exhibited his paintings in solo shows at White Columns (New York), 356 Mission (LA), and the University of Kentucky Art Museum. His first piano/vocal record, *Lounge Act*, was released by Ugly Duckling Presse Records in 2017; he has given musical performances at The Kitchen, REDCAT, Centre Pompidou, the Walker Art Center, The Artist's Institute, and the Renaissance Society. He is a Distinguished Professor of English, French, and comparative literature at the CUNY Graduate Center in New York. His website is waynekoestenbaum.com.